God Blessed Them for the Journey

…A creative travel guide through
life's challenging journeys.

Corrine Lund, author
Cancer Survivor and Lover of Life

authorHOUSE®

AuthorHouse™
1663 Liberty Drive
Bloomington, IN 47403
www.authorhouse.com
Phone: 1-800-839-8640

First published by AuthorHouse 7/7/2009

ISBN: 978-1-4389-6208-5 (sc)

Printed in the United States of America
Bloomington, Indiana

This book is printed on acid-free paper.

All scripture references are from The New International Version Study Bible; Zondervan Publishing House; Copyright 1985.

Table of Contents

About the Author ix
How Amazing Is the Sound of Grace xiii
Opening thoughts... xvii
So let me begin this journey with you... xxiii

Section 1

And God blessed them and said... "Be filled in the new day I have
given you." 2
 Quieting your mind... 7
 Remembering and exploring your thoughts... 7
 The Calendar page... 9
 Try this with me... 11
 One more thing... 12
 A prayer for Beginnings... 12

Section 2

And God blessed them and said... "Keep your faith strong." 16
 Quieting your mind... 20
 Remembering and exploring your thoughts... 20
 The Calendar page... 21
 Try this with me... 23
 One more thing... 24
 A prayer for traveling... 24

Section 3

And God blessed them and said... "Trust my plan for your
journey." 28
 Quieting your mind... 31
 Remembering and exploring your thoughts... 31
 The Calendar page... 32
 Try this with me... 34
 Do the following... 34
 One more thing... 36

A prayer for trusting... 37

Section 4

And God blessed them and said... "You are becoming the person I
created you to be. Celebrate!" 40
 Quieting your mind... 44
 Remembering and exploring your thoughts... 44
 The Calendar page... 45
 Try this with me... 46
 One more thing... 48
 A prayer for growing... 48

Section 5

And God blessed them and said... "Have a Dream!" 52
 Quieting your mind.... 57
 Remembering and exploring your thoughts... 57
 The Calendar page... 58
 Try this with me... 60
 One more thing... 62
 A prayer for dreaming... 62
From Psalm 17... 65

Section 6

And God blessed them and said... "You are created in my image." 68
 Quieting your mind... 71
 Remembering and exploring your thoughts... 71
 The Calendar page... 72
 Try this with me... 73
 One more thing... 75
 A prayer for exploring... 75

Section 7

And God blessed them and said... "Take my hand and join me at my
table." 78
 Quieting your mind... 82
 Remembering and exploring your thoughts... 82

The Calendar page... 83

Try this with me... 84

One more thing... 85

A prayer for the table... 85

Section 8

And God blessed them and said... "Slow down! You're running ahead of me!" 88

Quieting your mind... 92

Remembering and exploring your thoughts... 92

The Calendar page... 93

Try this with me... 96

One more thing... 97

A prayer for slowing down... 97

Section 9

And God blessed them and said... "I'm giving you a new beginning." 102

Quieting your mind... 105

Remembering and exploring your thoughts... 105

The Calendar page... 106

Try this with me... 107

One more thing... 109

A prayer for hope... 109

Section 10

And God blessed them and said... "Be my hands and feet." 112

Quieting your mind... 115

Remembering and exploring your thoughts... 115

The Calendar page... 116

Try this with me... 118

One more thing... 119

A prayer for hands and feet... 119

Section 11

And God blessed them and said... "Ask and it will be given to you, seek and you will find, knock and the door will be opened." 122

 Quieting your mind... 127
 Remembering and exploring your thoughts... 127
 The Calendar page... 128
 Try this with me... 130
 One more thing... 132
 A prayer for reaching out to a real God... 132

Section 12

And God blessed them and said... "Welcome Home." 136

 Quieting your mind... 139
 Remembering and exploring your thoughts... 139
 The Calendar page... 140
 Try this with me... 142
 One more thing... 143
 Prayer for "going home"... 143

Devotions for Each Day ... 145
 Just one more thing... 155
A Prayer at the Close of the Day... 160

About the Author

Corrine Lund, author of <u>**God Blessed Them for the Journey**</u>, is a wife and a mother. She is newly retired after a career as an art teacher for students of all ages and abilities – kindergarten through college. As both an artist and educator, Corrine learned that her education and teaching experience of twenty-five years opened doors to many unexpected opportunities.

Corrine is also a cancer survivor. She used her creativity for support throughout this challenging time as well as to "have a little fun" on this most significant journey. It is because of her experiences with breast cancer that she decided to share her ideas through this book.

And the growing process continues. "I have had an opportunity to go beyond simply learning skills and techniques. It's been exciting to explore and experience the healing power of becoming involved in this creative adventure. Life is a process...often a process with many surprises. I've learned that exploring my creative interests made my life more meaningful and even healthier. It also helped give me insight into the person God created me to be on this amazing life journey."

In the process of writing and creating in one of her many journals, Corrine added her handprint to each journal page. She squeezed ample amounts of acrylic paint onto a large paper plate, choosing colors that seemed appropriate to that day's entry...some days called for bright, cheery colors while other days were dark and moody. Occasionally there

was even a need for a touch of glittery gold paint! Corrine wiggled her open palm around in the wet paint, mixing the colors and stamped a full handprint on the page, then writing in the space left around the handprint. Somehow, becoming physically involved with the paint was almost as therapeutic as the actual writing. "Feeling the thick paint on my hand seemed to relieve the stress of the moment and sometimes added to the playfulness of the process," Corrine described.

God Blessed Them for the Journey is a book that can be read and used as a workbook over an extended period of time. Included are a variety of creative experiences that Corrine continues to use on her own journey. This is a workbook that is meant for anyone and everyone... people who would like to explore the power of the creative process whatever their challenge or life situation or whatever their creative abilities might be. This is the story of a journey with breast cancer along a path that led to an ever deeper sense of awareness and joy. It is a story of being awakened to God's surprises in her life.

To my daughter, Rachael

*Thank you for encouraging me to
explore my dreams!*

And to my husband, Art

*Thank you for encouraging me by saying
"Of course you can do it!"*

How Amazing Is the Sound of Grace

AMAZING.
GRACE.

HOW SWEET THE SOUND. Sweeter than anything I could ever imagine. I once was lost but I have been found!

AMAZING GRACE!

Sometimes I am overwhelmed by the world in which I live, stimulated to the point where my head spins! I can't comprehend all that goes on around me. Often I simply think – ENOUGH!

Grace. Somehow this amazement is different from everything else in my life. It rumbles through every cell in my body. It saturates my whole being. It rings in my ears, beats in my heart, flows through my veins and yet, it simply gives me Peace.

AMAZING.

GOD IS. An incomplete sentence with a totally complete thought. GOD IS. And because God is...so am I. So I am.

The shaping of a clay pot cannot be separated from the artist nor can I, a child of God's creating, be separated from my Creator.

AMAZING.

In absolute perfection I was created and blessed with a purpose for my life. How do I know what that purpose is? God made a promise to me that not for one moment would he leave my side. In a creation of millions and billions of plans, he promised me that I would have

individual attention in order to discover the unique plan he has for me.

AMAZING.

So I continue working out that plan for my life...sometimes in the dark and sometimes in the light but always with individual attention given to me from my Creator. Sometimes I listen and sometimes I don't.
 BUT...ALWAYS I am loved by my Creator.

AMAZING.

Sometimes I just can't find my way. The dark becomes so heavy that I wonder if there even is light.

I ONCE WAS LOST...

BUT...I was found. I didn't find myself. I WAS FOUND!

AMAZING.
GRACE.

God's gift. All I need to do is to be still and listen in order to know that God loves me.

HOW SWEET IT IS.
HOW GENTLE.
HOW CALMING.

AMAZING.

I once was lost.
Lost in a world so busy that I didn't know where to turn or how to be still.
Lost in a world so busy that there was no time or place for peace or grace.

And yet…here is God's gift to me. In my quietness or in my distress God says, "Please accept this amazing offer."

AMAZING GRACE.

AMAZING…not really.
IT'S GOD'S PROMISE!
TO ME
AND YOU.

Opening thoughts...

Doesn't it seem as though our lives are governed by schedules and calendars? Wednesday arrives and we are already halfway through another week. We turn around and it's TGIF! Friday again. Another weekend is upon us. Before you know it, Monday has come 'round again.

There is usually one day during the week when I can be a bit more relaxed in my routine. It might mean sleeping later in the morning or staying up later the evening before. Maybe it's the clothes I choose to wear, lounging in my bathrobe or a sweatshirt and jeans. Whatever the situation...it feels good being home, just being "myself".

When I consider who it is that I am, the creation story in Genesis and the verses in Psalm 139 become totally awesome. Simply consider the physical aspects of our bodies...the beat of our heart, blood flowing through our veins and breath passing through our lungs. It is even more difficult to comprehend the unique personalities God created to suit each one of us. What a journey – learning about who we are in God's eyes and then accepting this person that he has created us to be! One day at a time – learning to listen to God and being open to his plan.

Life seemed to have been more carefree when I was growing up. Of course, I am remembering life through a child's perspective but I do believe that sixty years ago, it was a simpler time. Violence and destruction didn't monopolize the news – but then on the farm we didn't

have television and we didn't receive a daily newspaper. My parents knew everyone in the county as well as where those folks lived and what they were doing – but in sparsely populated northern Minnesota, knowing everyone was not a daunting task!

Home was comfortable and safe. We didn't lock our doors. In fact, neighbors would open the back door after a quick knock, walk in and call out "Anybody home?" Generally, someone was there with a "Sure, come on in!" Our home was a good place to live and the homes of others were comfortable places to visit.

God spent a great deal of time creating an earthly home for us, his children. He made provisions for day and night, a time to rest and a time to work. He provided resources for food and shelter. God made our earthly home incredibly beautiful. Into this amazing place he put us, his children. He created us and blessed us and welcomed us to our new home. God made a home for us, a place where we are able to grow and become the people he had planned for us to be. God invited us in and said, "Be comfortable. Make yourself at home!"

It didn't take long for us to consider the possibility that we could make some changes and maybe even improve on these living conditions... wise people that we are. Life became more challenging. We began to lock our doors and look over our shoulders. It became more difficult to understand the unique personality that was developing within each of us. It became a challenge for us to discover the path for our own personal journey.

The story did become more challenging but even so, God continues to issue the same invitation. I have shared ideas in my writing about God's open and ongoing invitation, looking at who God created us to be. We all stumble and our lives do become cluttered. God, in his caring way, helps us to get back on our feet and provides guidance as we sort through the clutter.

There are so many blessings God has put before us. As I am reminded daily to stop, to be aware of and to enjoy these blessings, I would like to invite you to join me as we explore twelve specific blessings concerning this journey of learning about ourselves as God's children.

You decide what will be the best way for you to use this book. It is designed so that you could focus your thoughts on any one section over the period of a month, for instance, resulting in twelve unique

experiences. The order in which I developed these sections made sense to my way of thinking but you might find one particular topic relates to another topic in an order different from what I chose. Let it suit your needs and your particular time frame.

Each section has been developed around a particular blessing and scripture selection to introduce that phase of the journey. Based on the blessing and the scripture, I have shared some personal thoughts with you, followed by a short meditation called "Quieting your mind" and a space to make notes called "Remembering and exploring your thoughts".

Next you will find a "Calendar Page" where the activity is focused on the theme used throughout each particular section. Following the calendar page I have invited you to explore an idea called "Try this with me…", once again based on the theme of the section. To conclude each section I have chosen a thought from scripture followed by a prayer that reflects back to the blessing.

It might be helpful for you to mindfully choose a specific time of the day to become involved with this section. Maybe your style is to enjoy a cup of coffee in the morning or pause for a bit in the evening before going to sleep. Could you develop a plan to do your calendar page to coincide with one of these? Make this time important enough to you so that you will remember to "work the creative process". This isn't wasted time…this is a time for you to quietly step away from your busy day and reflect on what is happening in your life…how that puts its mark on who you are and what you are doing. Put this activity into the routine of your day and give yourself permission to be mindfully present in each day.

A few more words on the "creating" section… I started numerous projects over the years. Some were long-term commitments and others were creative adventures that I could pick up and put down on short notice. I would work on projects in the car while riding a long distance or, at other times, relaxing at home in the evenings. Even as a child I loved being involved with hands-on experiences; making, doing, cutting, pasting, building…and that has continued into my adult life.

Consider taking on a creative project that is new to you. Could you develop a plan and possibly follow the seasons with this idea, beginning in the spring and working through to harvest, maybe planting a garden?

Maybe you could explore a new craft. What about learning to knit or weave? Could you see yourself creating a quilt or constructing a piece of furniture? Learn to play the piano or guitar or join a singing group in your community. Write a book! Maybe you will shine in the kitchen!

Whatever the plan, consider extending an idea over the course of several days, weeks or months. Whatever the plan, move in the direction of developing your own creative interests. The creative process is for your personal growth. A gardening project would be good but cleaning out the garage might not be as fulfilling or rewarding. Or maybe it would be...

In the process of this "process", consider the beginning and the culmination. Be aware of how you felt learning/experiencing a new creative process. Listen. Be aware of your fears or concerns. Celebrate the joy of accomplishing something new and different. Relate it to what is happening in your life right now and allow it to be a means to express your thoughts about your journey.

Remember, the creative process has nothing to do with becoming an "artist". Research has shown that it is "healing" to become involved in a creative experience, so this is simply about creating for your own personal growth. And there are no rules. This can be an experience just for you or you might want to invite a companion to join you in the process. No rules – just ideas! Explore. Become aware of the abundance of blessings God has bestowed upon you. Take time to ponder this amazing person you have been created to be in this place God has made for us.

Read. Meditate. Create. Explore. Pray. Reach out. Soak Up. Enjoy. Do you know the song "Surely the Presence of the Lord is in the Place"? A favorite part of the verse for me goes: "I will linger, I will stay, in his presence everyday...that his likeness may be seen in me." As you read the words in this book, think quietly through the devotions and actively become involved in the creative process as you remember that surely the presence of the Lord is with you in this place...and that his likeness is seen in each one of us. Indeed, he has blessed us all in amazing ways.

Thoughts to ponder as I begin...

God, you have a plan . . .*Help me understand it.*

God, you have a plan . . .*Help me learn from it.*

God, you have a plan . . .*Be patient with me when I feel such a need to complain.*

God, you have a plan . . .*Comfort me. Open my eyes and and my heart so I might always be aware of your plan.*

God, you have a plan . . .*Help me see myself in that plan.*

Pause a moment and jot down some ideas about God's plan for your life...

So let me begin this journey with you...

One day my daughter said to me, "Mom, did you know there is an onion on your desk?" With a definite element of surprise in my voice, I responded a bit defensively, "Yes, I'm aware of that." Naturally, her next response was "Why would you have an onion on your desk?" At that particular moment, I couldn't come up with a good answer to her quite logical question. If she were to ask that same question of me today, I would be able to tell her the tale of the onion.

Naturally, your question will be "So, why was the onion on your desk?" I still can't remember how the onion came to be there but I can tell you why it is important for me to be aware of that onion on this particular day.

The day my daughter first noticed the onion, it was wrapped in a thin brown papery onionskin. Some sheets had separated from the bulb of the onion and had fallen to the surface of my desk. As that onion sat on my desk, it appeared to be dry and lifeless.

A considerable amount of time passed since my daughter had commented on that onion. I had forgotten about it, until today when I glanced to the side when I was working at my desk… there it was. To my surprise fresh, long green shoots of new growth were sprouting upward from the onion that had at one time appeared lifeless. (There is no doubt that onion must have been on my desk for a special purpose!)

My heart had been heavy for a long while. Life had been somewhat challenging but maybe that is the situation we get ourselves into sometimes. There had been days that I most certainly resembled that onion in its earlier state…appearing to be dried up and lifeless. During this period of discomfort, God remained quite persistent. Daily there had been signs of encouragement. Daily there had been signs that there was hope that would eventually bring change.

Some days I do tend to turn my head…and heart…away from God's encouragement. But, today, on this cold snowy January day when I am first putting together these words, God was once again giving me a sign of encouragement. I must say God was certainly displaying his sense of humor in doing it through an onion!

Thank you, God, for that simple onion. I would like to reassure God that I will promise not to turn my head away or close my heart ever again but I don't think that is realistic. But today, God, thank you for your smile. I hope you noticed that I smiled back! There is hope for change and each day we are reminded that the change can begin within us.

When I was a young person growing up, I did not devote much time to reading my Bible. There weren't many books in my childhood home. The stairs going up to the two small bedrooms in our farmhouse were steep. At the bottom of the stairs was a shelf, under which was a small cupboard. In that cupboard were two old Bibles. Those two books rarely left that cupboard. I didn't think much about the stories that were on those thin, difficult to read pages. As I grew older, I learned the stories but I seldom reached for that book even when I found my heart filled with questions.

It was many years later during another period in my life that I once again resembled that dry and lifeless onion. This time I had pretty much kept my lifelessness hidden on the inside. One night, during that difficult time, I awakened in the dark, filled with an incredible sadness and fear. I was alone and there was nothing or no one, it seemed, to whom I could turn. So…that night for some reason, I turned to my Bible. I sat there, in my bed, alone, and began to read…starting at the beginning.

This universe had been so very empty and dark…even without form or shape. Then the Spirit of God came upon the darkness and there

was light! And it was good! God didn't stop there. He made mountains and rivers and trees and animals. Right from the beginning God had a creative eye. As all these things took form, God made one more amazing piece of work…he created humankind - you and me. And this he did with a very specific purpose in mind.

Even though I still turn my head and close my heart at times, the purpose for my life continues to be there. God breathed into me and said, "Please take notice of all that I am doing and that it all has a purpose and you are a unique part of that purpose. Remember especially that what I am doing is good!"

Why do we need to be reminded so many times that there is light in the dark? Lord, today I lived through the message in the onion. Thank you for those tall, bright green sprouts of hope. Now, God please give me the guidance to live in the hope of that message.

This evening, before I sat down to write, I was working on my own "creating", in a space reserved for messy projects in my basement. My fingers are smudged from the blue dye and I am still wearing my paint spotted shirt. Actually, I am making a gift…a batik. It is a time-consuming process. One step must be completed before going on to the next step. God probably worked in much the same way…creating, checking it out and then creating a bit more. Periodically, I stop and evaluate what I have already accomplished. Then, slowly I move on and will eventually complete the process.

Creating, the actual process of making something, is a very satisfying experience for me. Being in the early years of my sixth decade, it seems I require more time to be still…more time to ponder what is churning around in my head and my heart. I feel a sense of peace when I'm involved in my creating. It becomes a healing process as well as a creative process, and it begins to clear my cluttered mind, calm my overloaded heart and relax my tense muscles.

Now, in my senior years, my Bible is coming apart at the seams. I've written in it, packed it in bags, purses and suitcases so it is no wonder that the binding is tattered and coming apart. Where the Old Testament pages begin with Genesis, I have taped in a page that states "It is God at work in me" taken from Philippians 2:13

It is God at work in me and in you. There is nothing we do on our own. As I form clay pots on my wheel or spread hot wax on my batik…

it is God at work in me. As I write at my desk or use watercolors at my table, it is God at work in me. God is working in me! The very God who made countless stars and filled the oceans and created my favorite place in Maine…that same God is within me helping me as I create. I haven't completed all my projects yet. There are ideas in sketchbooks and incomplete projects on shelves. Somehow, I don't think God has set aside his supplies either. God's work is ongoing but what an amazing "finished product" there is in store for us!

There is an interesting concept that has been expressed by numerous writers and thinkers. Consider the thought that there is nothing in this creation of which we are not a part. God's first breath into Adam has also entered our lungs. The words God spoke to Abraham as they made the covenant together have also reached our hearts. Our God is an awesome God who has taken up residence in each one of us…right from the very beginning.

Now the problem with us seems to be remembering and being aware of God's presence. The problem is learning to recognize that a cluttered mind and an overloaded heart, tense muscles and heavy shoulders might mean that I am working on my own. God didn't intend for life to be dark and heavy. God didn't intend for us to work alone. God created us for the Light and he created us to be in partnership with him.

What we are invited to remember each day, whenever we are doing anything, is that we do nothing on our own. Our rising up as well as our resting, going to work or taking time for play, our making and our doing…all are done with God in every heartbeat.

As I mix my dyes to get just the right color or crackle the wax so that the dye can permeate the fabric, God has a hand in it. As I choose the words to express a thought on paper, God inspires me. As I look at the message in the onion, God's presence reminds me that there is hope. There isn't a moment too insignificant or a task too daunting that God is not willingly in partnership with me. How much more rewarding and pleasurable the task becomes when I remember and sense his presence.

Genesis 1:1 says "In the beginning God created the heavens and the earth." That is pretty much everything as I understand it. In a "few days", however long those days were, God made it all…the light and the dark, the water and the dry land, the fish that swim, the birds that

fly and all the creeping and crawling creatures in-between; the sun; the moon; and the stars...God made it all.

Then in a moment of need in God's own heart, God recognized the importance of having a companion with whom to share all this creation. And...here we are! It's been some distance down the road since this idea began but, nevertheless, God created me to be in partnership with him in all that I do. And God promised that I am never left alone to do it on my own.

I am a visual learner. Statistics and logic don't do it for me. I need images in my mind. Pictures. Hands on. Explaining the theory and theology behind God doesn't create a real presence for me. Better for me is visualizing God as the potter working with the clay on my potter's wheel. I see and feel that presence in images with paint and clay in my hands and the lusciously colored pages of handmade paper I enjoy creating. I sense God's presence as words come together and thoughts develop into images.

But, hearts can harden like clay when it is left uncovered. We aren't of much use when we are hard as stone. Think of that lump of hard clay being put into a container of water. Once the conditions have been made right to refresh the dry clay, the water is soaked up, oozing into every particle of that stone hard chunk. Under the right conditions, we can be made workable again. As we soak up that presence of God we are once more made pliable, ready for our part in that partnership.

During my journey with breast cancer, I created a painting that is overflowing with symbolism. Whenever I look at it there is a new message for me. This painting, hanging over my desk (yes, the same desk where the onion sat) shows me standing in the palm of a large opened hand that reaches out from a body of water. The fingers of this hand are gently raised up around me as though they are protecting me. I am dressed in a soft purple robe. My bare feet are standing in the center of the palm of this hand...standing in a place stained red. My bald head, bare from the chemotherapy, looks upward out of this hand. It is a moment of revelation, a beginning point, a fresh start.

I don't know why it took me so long to discover who it is that I was created to be. It should have been pretty simple at the moment I sucked in my first breath. Those early moments are no longer in my conscious memory. As I grew, no one ever talked about my birth or my first breath

and I never asked. I don't know if I struggled to begin this life or rejoiced with a loud cry as I entered into this life journey and received the name that would identify me.

I was probably just another one of God's children, struggling for an identity and a purpose. My mother's dream was that I become as efficient as she was and my father's dream was that I had been a son rather than a daughter. So, in my beginning I traveled along my path, experiencing my journey as an "inefficient female", not recognizing that face I could only see dimly in the mirror. Not a healthy beginning, needless to say. It took – and is still in the process of taking – a long while to recognize and accept this person I was created to be.

So this painting, created at a critical point in my life, was a new birth, a new beginning. It is as though, in this painting, I am rising up out of that stain – standing there as the person God did create me to be. Finally I am recognizing that faint image in the mirror. I know that I am not alone in this experience of "identity crisis" or "identity loss". I know that I am not the only one who has searched for a call in life, a specific purpose.

But I also know something else…something incredibly amazing… God already knew <u>me</u> as he breathed life into those very first creatures. God knew <u>my</u> heart and soul at that outpouring of breath in the very beginning. As I gasped for my first breath, God was blowing his breath out…breathing into my lungs…and on my forehead he was writing my name - Child of God. Even though no one described my first seconds of life or shared the story of my name, God was there as I rose up out of his hand to become a creature in his world. God didn't see an inefficient female. God saw me and said, "She is very good!"

Beginnings happen frequently, in various ways, and continue all through one's life. Beginnings can be distressing and discouraging as we think of starting over. Beginnings can also be refreshing, yet another opportunity to try again. Beginning again can save one's life.

My story, the "discovery" of who it is that God created me to be, didn't begin until I was in my 50's. Imagine – fifty years of practice and then the real "eye opener". God breaths that first burst of air into our lungs and what we call "life" begins. It is when God moves into our dried up hearts that we really experience the joy of Life. It is when

each of our hearts finally open that we experience the beginning that God had in mind for us.

As we walk through the journey of this book together, I will be using as a foundation several thoughts from both the Old and the New Testament, thoughts to tie this all together. Throughout life it is important to remember that God does know us. It is important for us to remember that God was not only there in the beginning but also is there on the long walk through life. In the hands-on process of living, as we work through all that God has put before us, we find it important to explore our creative potential in life, a part of life that God also gave to us. It is important to remember that on this journey and in the midst of the work God has promised, we can trust him with all aspects of our life. God has provided numerous experiences for us to explore in this world.

Sometimes we do get bogged down and it is slow going. We do get confused, frightened, discouraged or think that the journey is all about us rather than our servant-hood. Doors do close. Hearts close. Life becomes painful when we travel alone and we rely on our own power.

Do you remember the painting of Jesus, standing at the door and knocking? The means for opening the door is on the inside – in our hands. If you recall this painting, Jesus is not breaking down the door. My guess is, if there were a second painting to follow this one, it would show Jesus with his hand reaching in to us saying, "Here, take my hand. I will show you the way home."

Simple, isn't it. Why do we persist in making the whole journey up-hill? Why are we determined to tell God that we'll take over from here? What makes us dead-bolt the door to our hearts? That certainly was not God's plan. In the beginning, God saw the whole picture. God had the Promise ready even before we needed the rainbow. God promised us a place in his heart even before we needed the Cross. In the beginning, God had a promise and he knew that it was very good.

My plan is to share some time with you. I have some thoughts about what we could do with that time, some ideas to share, and several creative opportunities for you to explore in your own time. Mind you, I am not trying to make an artist out of you but rather offer some ideas for you to explore in a creative way.

Maybe this is a book about slowing down…enjoying the time that has been given to us. So often, I think back to the Beginning…how God took the time and created time. I am a fan of calendars. On my refrigerator I have a beautiful calendar with the words of the Lord's Prayer. On my desk I have a large calendar where I make notes of just about everything I need to do or should remember. But my favorite calendar was one I made myself. Because of the words I added and the cover I created, it became very personal.

In the beginning there was no sense of time as we think of it today. God didn't check his watch or calendar. God didn't consider end of the month demands or annual reports. The Spirit of God was hovering everywhere…all the time. Thinking about God being that visual certainly conjures up a pretty cool image in my mind. The Spirit of God, hovering everywhere, all the time! For many "days" God created for one purpose…to make a place for us, the focus of his love.

God's purpose is clear in the opening verses in Ecclesiastes… "There is a time for everything under heaven" and each experience is described. Time to work and time to rest. God didn't create the world in the blink of an eye. God must have thought and planned and then thought some more. That is another powerful visual image!

Oh, that I remember that as I begin each day and again as I pull the blankets up around me at night. As I turn that around in my heart the words speak two thoughts to me. In the day that has been given to me, there is time to do what needs to be done and then there is time to rest. I must also remember that there is going to be a time for those things that happen "to" us – the challenges and changes, illnesses and various health concerns, new life and eventually death. Often times these challenging life experiences are not what we would choose to deal with at that moment.

There is a time for everything and a season for every activity under heaven. Often we don't feel there is enough time in our day or week to accomplish all that needs to be accomplished. What I didn't realize was that I often filled my plate too full…much like overeating. Many times in my life I wasn't ready for what unexpectedly appeared on my plate.

There is a time for everything and a season for every event under heaven. How amazing is our hindsight – how clear our vision looking back over our lives. In each event, for me, the time was right and during

each experience there was direction and guidance. Just like those people moving across the desert journeys with Abraham or Moses, each time I needed to walk through the desert the time was right and there was guidance and manna for the day. How much those wandering people remind me of myself. How guided and blessed I have been! It's time to stop filling my plate to overflowing, time to stop grumbling and time to stop sitting in the dark. It is time to recognize how blessed I am and to be aware of the manna that continues to be set before me for this day.

EVERY DAY…every day – *I will praise your name. You have blessed me with more than I can ever comprehend.*

EVERY DAY…every day – *I will be still so that I can consider the gifts you have placed before me. As I remember these gifts, I will be aware of the responsibilities that accompany them. I will work at growing and maturing in my life and will then respond to your gifts by sharing with others.*

EVERY DAY…every day – *I will remind myself of your plan. You have made it very clear. I am the one who contributes to the confusion.*

EVERY DAY…every day – *I will acknowledge the fact that life is not always perfect, but with you, I can learn to handle the imperfections that sometimes become a part of my life. Help me to focus on my blessings rather than my problems.*

EVERY DAY…every day – *God, each day, give me a hug to keep me going and then remind me to pass that hug along to someone else.*

*And I will celebrate in your presence…**EVERY DAY.***

Section 1

And god blessed them and said...

Be filled
in this new day
I have given you.

And God blessed them and said...
"Be filled in the new day
I have given you."

In the beginning God created the heavens and the earth. Each new day began with God "speaking" something into place...first the light and the dark, then the water and the dry land. God spoke again and plants burst forth from the earth. The sun and moon and stars appeared. There were creatures of every kind imaginable. Then God spoke one more time, "Let us create humankind in our own image."

From the beginning, God knew me. I can't walk across the room but what he is aware of my purpose in doing so. Before my mouth opens to speak, God knows my words. God begins each morning with me right from the moment my feet first touch the floor. God is there to guide and encourage, to support and sustain, not to condemn and criticize.

My husband and I had recently moved to a new community...an unfamiliar house, furniture rearranged, curtains on different windows and rugs on new floors. A new beginning! All around the backyard of our "old" house there were new shoots of the small tree, Rose of Sharon. Seeds had fallen to the ground and small green branches were sprouting up everywhere. I decided a bit of transplanting was in order, bringing some of the old and familiar to our new back yard. The home we left

still belonged to us so in the fall I made a trip back to collect some of these small growths. I carefully transplanted the fragile branches into the new ground at the end of that first growing season in our new home. As the first heavy snows of the winter arrived, these new branches were quickly covered.

Spring arrived and sadly, I decided that winter had been too hard on the transplanted bushes. Not a sign of life. Then one day, while clearing away dead fall leaves from around the branches, my eye caught a tiny piece of green, low down on one branch. I looked again and there were signs of new growth. Small fresh buds were coming to life.

I had been praying my way through all these changes in our lives. Moving can be a challenging experience. There were days when even the heaviest of clouds could not have darkened the sun and then there were days when all I felt in my heart were storm clouds. There were days when I simply said to God, "You really don't know what you are doing!" And, with even greater frustration, I would add, "And God, I don't think you even care!"

Surprising things began to happen – extraordinary, yet simple things. Unusual things yet they seemed so commonplace. I haven't told you my feather story yet but some days I would spy a tiny feather on my path and would once again be reminded that God did care and most certainly had a plan. I would remember the green buds that emerged fresh out of the branches that appeared almost dead.

How does one know when God answers a prayer? We have been brought up in our modern culture to be confident in our own strengths and abilities. Up the ladder of success we climb, one rung after another – almost out of breath but doing it on our own. How do I really know that it is God who guides and directs me as I plant each foot securely on that next step? Do I have to experience the deep dark places in order to learn? How do I know that it is God guiding me through that experience, traveling through the dark into the light?

I often think back to the Genesis stories. Remember the story of Abraham, flowing robes and blowing sand as he was tending to his life in the desert, caring for his wife and all that he owned? And then in Genesis 12:1 God talks to Abraham. "Leave your country, your people and your father's household and go to the land I will show you." God goes on to tell Abraham all God will do for him. Abraham didn't even

know the location of this land! Then an amazing thing happens. Genesis 12:4 reads "So Abraham left, as the Lord had told him."

That is an incredible conversation. Do you remember how, in the Beginning "God spoke"? Well, here he is, doing it again. Genesis 12:1 doesn't say that God left a voice mail for Abraham, while he was out tending his huge flocks and herds of animals. The words are clear. God "said" to Abraham just as God "said to the seas and the sky and the creatures."

Now, just as incredible, in my way of thinking, is what happened next. In this amazing exchange between Abraham and God, Abraham receives some quite specific directions. God said to Abraham, "Leave everything that is familiar to you. Leave the place where you grew up, leave the home of your family and the people you have known all of your life. Leave it all!"

For what? For the promise God made to Abraham. God was making a plan that would cause Abraham to become the seed of a whole nation. God would guide Abraham, protect him and bless him. I'm not sure I would have considered being uprooted a blessing. Moving is just plain hard work!

The story doesn't end there. Abraham "heard" what God was saying to him and Abraham "believed" God and - are you ready for this – Abraham "did" what God told him to do! Leave everything? You have to be kidding! Abraham had worked hard for all those sheep and cattle. He had responsibilities. How could he think about being the Father of Nations when he wasn't even the father of one!

God "spoke" and all of Creation came into being from formlessness and void. God "spoke" and Adam and Eve knew who they were. God "spoke" and Noah built a huge boat when there was no water in sight. God "spoke" and Abraham began a long journey.

How did they <u>know</u> it was God speaking, providing them with such remarkable messages? Abandon the garden. Build an ark. Leave your homeland. God "spoke" and they knew it was God!

When I am burdened with a concern, have a significant decision to make or find that ill health demands all my strength, it does seem that answers and directions do come to me. How easy it is to think that the answers to my needs and concerns, my burdens being lifted or my body being healed are all a result of my own infinite wisdom.

Piece by piece, reflecting on one experience after another, I am gradually able to separate God's infinite wisdom from my self-pride. God still speaks. There is evidence wherever I look – small green buds on my trees, finding my way out of the dark places and enjoying the strength that comes after a significant illness. Piece by piece, I come to know and not to question, to clearly recognize God's hand in my life and to trust in his plan.

God is in the business of speaking to us, answering us when we call out to him. Answers may take time and might be a surprise but God does speak to us! Often it is my hindsight that makes this evident. I am frequently arrogant enough to think that in this present moment I am capable of finding, planning and traveling my own path. My trust grows in living today and my faith grows in having yesterday to reflect upon.

So, because of all the yesterdays I can begin today with confidence. I can live in the assurance of knowing God has a hand in every new day I experience. As I give each new day to God, right in the beginning before my feet even touch the floor, I will become more and more confident in God's plan for this new day, hearing God speak to me today, trusting in today and recalling the blessings of yesterday to confirm his presence in my life.

So, God, it is a new morning and I am listening. Help me as I talk with you each morning and reflect on the blessings you bestowed on me yesterday.

At the beginning of this new day, God, help me to get it right from the very beginning! I am not always a good listener. I tend to interrupt. What if, today, right from the beginning I allow God to fill my day? What if I really believe God is going to keep that promise of caring for me – all day! What if I really believe God is at my side and in my heart assisting with whatever tasks that are on my plate today, as much a part of the day as the rain on the window and my warm robe around me.

The day is beginning. Lord, open my mind and my heart and my soul to the fullness of your presence. You are God and I'm going to need help with this day. There is nowhere I can go today where I am separated from God. God has placed his hand on me from the beginning. God's hand guides me and holds me up. God takes me by the hand and leads me. I can find rest in God's hands. Amazing.

God created me...in the beginning. God spoke and I came into being. God breathed into me and I became a Child of God. God put the skin over my inner parts, made my ears and my eyes, my heart and my soul and wove it all together to create me just as I was meant to be. God created me and has a plan for my life. All I have to do is listen and day by day, God will continue to take my hand in his. God will guide me in the direction that I am to go. God will know my every move.

God speaks...right from the beginning of each new day. The problem comes when I don't pay attention! Each new day that God sets before me needs to begin with me listening, listening to God's words for that particular day. God doesn't awaken me to remind me to worry about yesterday or to encourage me to fret about tomorrow. God simply promises guidance for this day. I am reminded to listen, whether the voice comes to me from the mountaintop or from the desert, from the light or the dark.

And God said, "Be still...listen...and know that I am God!"

Quieting your mind...

In the beginning, God spoke. As humans, we do struggle with listening. We would rather be the ones talking. Lord, help me to be still at the beginning of this day so that I know you are God.

In the beginning, God had a plan and it was good. The day and night, the sun and the moon, the plants and animals were all created "good". I seem to have such a need to improve upon God's plans. Lord, help me to trust in your plan and to recognize that my good ideas come only from your infinite wisdom.

In the beginning, God made a promise that as humans, created in his image, we would always be his children. God promised to guide us and care for us. God is known for keeping his promises. Lord, help me to accept and understand the timetable of your plans. You promised that as your children, you would keep your arms around us and each day you would hold us up.

In the beginning, God must have felt such joy as his plan began to grow and take form. Like the anticipation of the birth of a child, he must have envisioned the pleasure of being a parent. Right from the beginning, God planned for us to rejoice in the life that was designed just for us. Lord, help me to be truly filled in this new day you have given me. This is another day you have made. In the midst of all I am doing today, I will rejoice and be glad in the day you have set before me.

Remembering and exploring your thoughts...

(Just to get you started...
This might be a space to rethink some of the ideas I shared. Maybe one of my comments is an "aha" moment for you or just maybe you disagree with me. That's okay! It might be something that came to mind as you were reading and you want to make a note so that you can think back on it later. Hopefully something I brought up will help you to take the idea

one step further…making it your own. Each section will include a personal experience and usually a story from scripture that relates to my journey. Consider how you might respond to either.
…That's what this space is for…your own thoughts.)

The Calendar page...

God spoke…and time began. God spoke and he created me in his image. Consider the days God has set before you. If it would be helpful, consider a specific amount of time, a week or a month perhaps. Begin each day by listening. Listening leads to awareness. Awareness leads to understanding. Understanding leads to a sense of peace in your heart.

This is a time to consider a new beginning. What is there in your life that you would like to "start fresh"? Each day we have the opportunity to "begin again". As my feet touch the floor, I hear God's word in my heart "Good morning, I'm here to help you with the day. Take my hand and let's get the show on the road!"

As you listen – all through the day, each day be aware of God "speaking" to you. I like reading in the Old Testament where someone has "talked" to God. I figure that if God talked with them, there is no reason that God is not going to talk with me! But the "conversation" might happen in unusual ways. I had lost an important address at work. After searching through one file after another, I finally set the problem aside. Instead I turned to some email that required my attention. After answering and deleting a series of messages, my list of emails on the computer screen stopped on a message that had arrived weeks earlier. It read "Thank you for your inquiry. So and so can be reached by calling this number or writing to…". Guess whose name was in the email! My frantic mind was stilled and there, on the computer screen I believe God was talking to me. "Silly", you say. I don't think so. What I need to remember is to be still and to listen…listen when God is speaking – however it is that he does it.

So, it's a New Day and you are going to find that special thing that requires a fresh approach. It might be a family situation or finding some time to spend with a friend. Maybe you have a project that just hasn't gotten off the ground. There always seems to be something to do around the house, inside or out. Maybe it is a dream that hasn't blossomed as you had hoped. Maybe it's time to begin…again, if necessary.

How about developing two directions as you think about this? Consider this: On what would you like to focus? Make some lists if you think that would help. Add and eliminate until you come up with something that calls out to you. (Remember, you are trying to be aware of that voice that calls out to you, guiding you in the direction you are to go.)

Once you think you know what you would like the focus to be, look at the calendar. You might even want to make or purchase a calendar specifically to use with this book – one with lots of space to write and make notes. Would you like to set time aside for this "Start Anew" project right off with the calendar blank or are there some important things that just need to be considered before you venture into the project or plan? Don't make this hard work! Set aside a time to do this for whatever amount of time/days you choose. Even if it is just for an hour…get started! Begin slowly. Talk it over with someone. Whatever your plan…get started!

There is room on this page to do some jotting down of ideas, a little brainstorming as you give this some thought. As you become actively involved in the process of this workbook, write in the margins or use any space that has been left blank. Sometimes, as I am reading, an idea comes to me and I think that I will remember it…but, guess what… it quickly slips from my mind. Tuck a pencil in this book…remember your ideas as they come into your mind.

Try this with me...

There are a million different ways to start the morning; the cry of a hungry baby, a dog barking because it needs to be let out right now, an alarm on a clock or the news on the radio. Morning can set our mind racing before our feet even touch the floor.

Consider this. Could you arrange your schedule so there is time for you to plan the morning, waking just a bit earlier so there is some time to be still...to slowly and mindfully allow the day to begin? Maybe this isn't realistic every morning but do you think there is even one morning during the week when there might be time to be still and become aware of God's awesome presence in this new day?

As your eyes open, truly "be still". If it is the radio news or music that awakened you – turn it off. Think about the process of your morning. Begin to create a plan for this new day. Don't rush into anything too specific. At first, it might be difficult to just still your mind. It might be difficult to tune out the demands of the world. Is there someone in your household who could share some of the early morning responsibilities so that this quiet time could be possible for you?

Imagine you are listening to a voice, speaking to you quietly from far away. Imagine that you have to concentrate to hear what this voice is saying. Be careful that you don't put words into the mouth of this voice. Trust me, if you listen carefully, this voice will speak clearly!

Gradually you will develop a sense of hearing that will be open to this voice telling you "Good morning", sharing a solution for a concern that has been weighing you down, rejoicing with you over an exhilarating experience or comforting you through an empty or lonely time.

Listen. Slowly, you will recognize this voice. God does speak to us, everyday, and he has a plan to hold us up. Be still and remember that God is in the business of giving guidance to his children. Be careful that you don't take all the responsibility for this "infinite wisdom".

And this is just the beginning. As a variety of creative experiences are suggested, come back to the calendar and to this page. Remain aware of beginnings or even experiences as predictable as morning. Remain aware of beginnings in your personal life as you relate experiences to others. Invite God in – right at the beginning.

One more thing...

Read Psalm 139...several times. Read the whole thing. Read it a verse at a time. Read it from the beginning to the end and then all the parts in-between. Read it and write about what it means to you. This is about YOU! God has known you from the beginning. Look back to Psalm 139 and note that it is written, "The Lord will fulfill his purpose for me." He is already busy doing this! We need to pay attention, be still and listen.

A prayer for Beginnings...

Lord, help me to set my feet firmly on the ground this morning. Help me to just put one foot in front of the other, one step at a time. I often want to run ahead, thinking that I know all there is to know. You know better!

Lord, help me with all the particulars of this day that require "new beginnings". I know that I can't do anything about yesterday or tomorrow. I know that I will have my hands full with today. If there are some "leftovers" to take care of, assist me in completing those tasks and help me to move on. If there are upcoming concerns, help me to give them to you for safekeeping. I don't need to fret about them right now.

Lord, if I am going to get started on the right path, walking in the right direction, I will need your hand to hold mine. I often act as though I know the way, but I sometimes pretend. Keep me honest in my actions and sincere in my thoughts. I know that you tell me to listen for your "still small voice" but sometimes I might need for you to speak up just a bit. I will work hard at listening but you know me...I need to be reminded. Put that

stone in my shoe to remind me when I start running ahead on my own path.

Lord, I am so glad you made me, breathed life into me and called me your child, way back in the beginning. Thank you for the fresh start that you put before me as a new day starts. What joy there is in realizing that you know me! In the beginning, when you first watched me open my eyes and take a breath, I am so glad that you looked at me and said, "She is so good!"

Lord, thank you for beginning this day with me.
Amen and amen.

Section 2

And God blessed them and said...

Keep your faith strong.

And God blessed them and said...
"Keep your faith strong."

I thoroughly enjoy getting the suitcases out of the attic and packing my belongings for an adventure on the road. My father was a farmer and that meant we weren't able to take vacations in the summertime. Actually, people didn't do much "vacationing" back in the years when I was growing up but in 1946 my parents and I did escape the frigid snowy winter of northern Minnesota. We traveled all the way to the southern most part of Texas. "Snowbirds", these Minnesota farmers were called in this Texas vacation community. Think about driving that distance without a AAA triptik, no interstate highway system, no motel chain to leave the light on for the tired travelers...not even a happy meal at the end of the day

After all these years, I remember the journey mostly from old photo albums filled with small square black and white photographs of memories...standing by road signs or markers showing that we had entered a different state, picnics out of the trunk of the car (before roadside rest areas), tourist stops in unfamiliar parts of the country. It was such a long journey.

We all experience various journeys throughout our lifetime, from the moment we first gasp for that breath of life. God does have a triptik for our journey and he does know the path well. He has generously promised to be a "rest stop" throughout the whole journey. I couldn't

begin to find the way by myself. Often, I manage to wander off on the wrong roads. Detours around "construction areas" consume additional time, generally resulting in mistakes that need to be corrected once one is back on the "right path". I need guidance, although I don't always behave as though I know that! We are on a journey of a lifetime and such an important journey it is. It is critical that we know the way!

The tasks involved in this journey are numerous and require a variety of preparations on our part. Can you imagine preparing for a trip from Minnesota to Texas in 1946? I find the thought of driving to Texas in 2008 a rather daunting task! Nevertheless, however long the journey, how extensive the plans and whatever the destination, all it takes is one wrong turn or an empty gas tank between towns to know for sure that I need to check that map more carefully.

Can you imagine what the people must have thought when Moses said, "Folks, we are going on a trip!" I don't believe scripture used the term "vacation". Moses complained that he wasn't qualified to be the tour guide. God knew what these people were like but I don't know that Moses really knew the extent and duration of this adventure. He just had orders to move these folks out of the jurisdiction of the Pharaoh. God had the plan and, creative God that he is, there were surprises all along the way. Surprises and a promise! These were his children and he had promised to care for them on this journey, however long and challenging it might be.

We all have experiences that are unique, unusual, difficult and challenging. Our traveling time varies. The ease with which we travel, what we learn on the way, and our focus on our particular destination will vary with each of us. BUT… the promise is the same for all those who believe and trust in following God's plan for this journey. The promise is that God does, indeed, provide guidance every step of the way, through the desert and through the green pastures.

Trust me, it is not always easy to understand and follow the map that is put before us. My daughter and I have learned that when we travel together we each have a specific role. When we reverse those roles, it can often result in disaster, maybe quite humorous, but nevertheless, it can be disastrous! She might respond, "Mom, don't worry, I'll recognize the road when I see it. I just can't find it on the map." Or I might say, "Don't worry. We won't think of that wrong turn as a mistake – it's just

an opportunity to see an area that we might not have planned to see." She is an excellent driver and I do well with the map reading. Traveling is often more enjoyable and less stressful when we recognize and assume our own role on the journeys we take together.

It's better, for my life journey, when I try not to assume God's role. It is wiser for me to pay attention to God's guidance and not correct God at every turn. When I am traveling and have a map in my hand, I trust that the markings are correct. If I begin to doubt whether the mile markers are accurate or if the name of the town actually matches the dot on the line...my trip doesn't go well at all.

As humans, it is natural that we are going to wander from the path. I am going to become distracted at some unknown turn. I have been known to refer to the wrong map and then pretend to know where we are. There are mornings when I go off to work or tend to errands, leaving home without a clear sense of direction regarding my destination, forgetting about the wisdom and guidance that I need from God at every turn in the road.

Saving for vacations has always been a special priority for my husband and me. We so enjoy looking forward to making plans to see some interesting new site or returning to visit a favorite place. The adventure might be a long weekend, a camping trip or perhaps a vacation several days long and many miles away. And plan we do. Brochures. Maps. Travel guides. Usually the miles, evening stops and final destinations are so carefully planned that there are few surprises along the way.

In 1996, as spring was beginning to work its way into our thoughts, we were already considering vacation plans. That particular year was to mark our 30th wedding anniversary. Then, very unexpectedly, a new journey changed all our plans. For this journey we had made no preparations, no dreaming or planning about the final destination.

After completing a routine mammogram, my surgeon said, "I think I should do a biopsy. There is something that just doesn't look right." A new journey was about to begin, one for which we were totally unprepared. Following the biopsy, the doctor quietly said, "I'm sorry but the tumor is malignant. It's cancer." At that moment she could just as well have told me that I was traveling to the next galaxy...without a map...alone...blindfolded...walking backwards in the dark!

My husband joined me in her office as she told us what to expect. We heard all the words and listened to the directions. Instead of excitement in my heart, as I would usually have with a new experience, this time there were tears in my eyes. I didn't know anything about this journey. I couldn't process this information. We left the office with a very different set of brochures and maps, ready to embark on a journey that seemed to lead only into the frightening unknown.

As a seasoned traveler, I knew intellectually that we needed to turn this journey over to God. I needed to trust in God's plan as my path made a very unexpected turn. I knew that I needed to trust in his plan and that he would provide the wisdom and the guidance that would lead me through this new and difficult experience. As I had frequently told my daughter when we traveled together, "I have managed to get myself on a most unfamiliar road." Indeed, this path was unfamiliar and most certainly frightening and I struggled to believe that God could be trusted and that he keeps his promises.

Your journey or experiences might be something very different from mine, something other than an illness such as cancer but still unexpected and unplanned. As you are either beginning this journey or reflecting back on such an experience, envision yourself on the path... now. Think of God as your traveling companion, your pillar of clouds by day and a column of fire by night, as Moses describes God's presence on the walk through the desert with the Hebrew people. Instead of fearing the wrong turns and roadblocks, try to visualize God just a few steps ahead, leading the way and clearing the path.

God's people complained and were fearful, even tended to be a bit bullheaded and stubborn as they traveled through the desert but God remained by their side. Day and night. Clouds and fire. God told his people, "If you will just listen to my words and do what I say, the journey will go as it should. I am the Lord who heals." Remember that...the Lord who heals, not necessarily cures but "heals".

God didn't say, "I will take all your troubles away" and he didn't say "I will cure you even before you begin your journey". No, instead he said, "If you listen and follow my way, I will be with you – all the way, and that's a promise." And so the journey began.

Quieting your mind...

Even though your experience might be something other than cancer, many changes along life's journey are unexpected. As you either begin to consider your own current journey or as you reflect back on where you have been traveling, envision yourself on that particular path. What does God look like to you as your "travel guide", your pillar of clouds or column of fire? Are you able to think back on the wrong turns and roadblocks? As you think of your current traveling through life, are you able to visualize God traveling just ahead of you, leading the way and clearing the path? Do you trust God as being a good "map reader"?

God's people complained and were fearful as they traveled through Egypt but God remained by their side. I'm sure they thought God must have forgotten about them as they wandered, thirsty and tired. Day and night. God told his people, "If you will just listen and do what I say, everything will be okay. I am the Lord who heals you." (Exodus 15: 26)

Remembering and exploring your thoughts...

The Calendar page...

As you began this workbook, the possibility of a vacation/adventure might have seemed to be a long way off. Instead, you might be recalling the excitement of past vacations or just wishing you could find time for a vacation or any kind of an adventure! How about a "mini-adventure...a one day adventure, somewhere close to home?

I live in a community that is still rather unfamiliar to me and I am finding exciting places practically in my own backyard. Every community, large or small, has something unique to see or do. It could possibly be a museum or a donut shop, an arboretum or a stained glass class, antique shops or an interesting library. There might be an opportunity to meet a friend for lunch at a local café, take a walk, join a class at the fitness club or wander about town for a little site-seeing.

If you do choose an experience in your own neighborhood, explore a bit and find something that really speaks to your needs or interests. It might be that you discover something quite different from your normal routine. Spend some quality time planning for this adventure. It might become a regular outing. Use a bright colored pen or marker and put this date on your calendar!

These journeys or adventures don't require packed suitcases and airline tickets. They don't even require maps and reservations. I watched a small child, about three years old, as he walked with his dad to their car. What an adventure they had! As this little boy neared the spot where the car was parked, he stopped abruptly in his tracks, spun around and set out in the direction from which he had come. After a few short steps he stopped, bent down and snatched up a very small flower. What keen fresh eyes he had to notice such a small part of nature!

We need to choose paths and plan adventures that will allow us to discover surprises with the enthusiasm of a young child. We travel, searching for surprises that are simple but surprises that cause us to become mindfully aware of the experience, recognizing the moment as a treasure for the day.

I have responsibilities and obligations but daily I remind myself that somewhere on my journey during this day there will be a treasure. In that treasure is a gift that God selected just for my growth, awareness and enjoyment.

A journey. An adventure. A surprise. A treasure. Mark these experiences on your calendar. Remember that gift. We must learn to pay close attention. We will walk this path but once. Mark your calendar as you open God's gifts!

Try this with me...

Remember...you have all the time you need to consider this project, this creative experience.

Pull out that drawer or open the box where you store all your old photographs. Everyone has photographs from special occasions and if you are like me, they get tucked away somewhere.

Find the photographs and refresh your memories. Choose an event that was especially enjoyable or memorable. If you are into the scrap-booking experience you have a head start in the process. If not, consider what means of displaying some photographs works best for you. It needn't be elaborate. There are some beautiful frames with multiple spaces for photographs to be displayed. You might choose a frame rather than an album.

Now take the memory refresher one step farther. Could you think about the experience and put together some words describing not just the time and place but how this particular experience "spoke" to you. What was happening to you at the time of this event?

> It might have been your daughter's first day at school or your parent's fiftieth anniversary. Maybe it is that special Grand Canyon vacation or gardening in your own backyard. It is always good to record the place and date but this time, reach deeper. Did you feel sad or proud or maybe both? Maybe the view was breathtaking, both at the Grand Canyon and in your backyard. Just take time to remember how you were feeling. Take the journey again, remembering, more slowly and more mindfully. There might even be some unexpected memories and feelings that come to mind.

If that worked well for you, continue the process with other memories. It isn't necessary to include every photo of every experience. The purpose of the process is the memory and how it spoke to you. What a treat...enjoying an adventure more than once!

One more thing...

Read Exodus 14: 19

"Then the angel of God, who had been traveling in front of Israel's army withdrew and went behind them. The pillar of cloud also moved from in front and stood behind them, coming between the armies of Egypt and Israel."

We are on our life journey everyday...through sunshine and storms, crossing deserts and climbing mountains and relaxing in lush valleys. Sometimes God needs to be out in front leading the way, giving us the confidence we need. Other times God brings up the rear, protecting and guarding us from whatever sneaks up from behind.

Don't travel alone. We all need encouragement and protection. The Lord, our God, is an experienced guide.

A prayer for traveling...

Lord, I'm usually excited to begin the journey for the day but I frequently start out on the path alone.

Lord, as long as the path is clear and my journey goes well, I usually pat myself on the back and say "I sure had a good day."

Lord, when I come across a boulder or two on my path, those pesky rocks too large for me to remove, I am pretty quick to call my heavenly AAA. You never fail to respond.

Lord, I thank you for your reliable response. You promised that right from the beginning.

But...Lord, help me to recognize my need for a traveling companion the moment my day begins. Help me to see you

as clearly when the path is clear and the journey is going well. Remind me that when I think I don't need help, it is simply because you are already there…out front, removing the boulders.

Lord, thank you for the encouragement and the guidance and thank you for the confidence and protection. Thank you for being my traveling partner – even when I forget to put out the invitation.
Amen and amen.

Section 3

And God blessed them and said...

Trust my plan
for your journey.

And God blessed them and said...
"Trust my plan for your journey."

Can you imagine what the Israelites must have thought when Moses told them they were going to walk right through the waters of the Red Sea! "We're going to do what? You have got to be kidding!" As our daily life experiences challenge us, there is generally not much we can do but meet them head on. Each step might seem like putting your foot into the Red Sea…will that wall of water, rising up on both sides, really hold until I pass through this?

Trust is so necessary in our lives. We go to bed at night, trusting that we will awaken in the morning. We send our children off to school, trusting they will come home safely. We give hours and energy to our jobs, trusting that the company will provide us with a paycheck. We trust our mechanic and our banker; we trust our spouse and our parents; we trust the court system and the government.

And, in all honesty, I do recognize the fact that there are times when we all probably feel like we just can't or don't trust anyone or anything. That's a fact of life, too. As significant as reactions to trusting might be, it is all really small potatoes if we don't trust that our God loves us and will support us when day to day experiences find our level of trust weak and wavering.

Sometimes those life experiences really do challenge our trust. When we step out onto that path with the wall of water on both sides, it can

be terrifying. God holds the water back as we move slowly through that experience. God knows us and is very aware of our fears. God knows that the unknown can overwhelm us. But…he also promises that if we put our trust in him, God will put a strong arm to that wall of water, whatever the challenge might be at the time. For the most part, I would guess that we generally move forward, one step at a time, meeting these life experiences. It's when that particular challenge becomes more than we can manage, consuming us in it's magnitude that we don't know which way to turn.

Learning about trust comes little by little, one step at a time. I am someone who has walked into that dry riverbed more than once in my life. God has repeatedly reminded me to trust. Wouldn't you think we would learn! Learning to trust that God had a plan was the only way I could begin to put one foot in front of the other on my journey with breast cancer.

Once I was aware of the diagnosis of cancer, I slowly began to understand and gradually adapt to a feeling of acceptance about this new and frightening experience. This "thing" had never happened to me. I was about to embark on a journey with breast cancer but in my heart I knew I was not traveling alone.

I think trust settles in when we are able to release our fear. There isn't room in our heart for both. Trust and fear are not good companions. Interestingly enough, the first way in which I began to release my fear was through tears. How very many ways God uses "water" – walking through it, being washed by it or allowing tears to cleanse us. I cried anywhere and everywhere as I wondered how I was going to handle a journey with cancer. The tears began to release my fear of what was to be ahead.

Eventually, the tears were making way for change. Those tears were a beginning step on this journey…a start. Slowly, I needed the tears less and less and I began to sense the warmth of God's arms around me. Tears at the beginning gave way to an incredible gentle calm that I would fall back on countless times in the days ahead. I didn't know what was ahead. Surgery, treatments, recovery time…I had no magic mirror in which to preview this process. I realized that there was nothing I could do but to trust – trust the physicians, the medicine, my decisions…and that God was doing this with me.

Trust is difficult to describe with words. Trust is a feeling deep in one's soul. I had been thrown an unexpected punch. I knew the sea was before me and the enemy was marching up behind me. Somehow, I had to have trust in order to cross over to the other side. I began to see the waters parting, making a path for me to put one foot ahead of the other. I committed myself to the care of my physicians. I listened to what they were telling me as we constructed a plan that would work for me. I trusted them. The journey began, slowly but surely.

These experiences can take our breath away. The Israelites were probably flabbergasted at the plan Moses (God, really) had but I bet even Moses was a bit overwhelmed as he shepherded those folks along that strange and challenging path.

God doesn't just stand by when our breath is taken away. I believe he puts tangible signs on our path, sighs that lead us to a growing sense of trust. I needed the tears, wet on my face, washing away the fears. I needed the encouragement, the cards, the hugs, and the phone calls. I needed the conversations that mapped out the process ahead – I needed those experiences in order to feel the trust building up inside of me.

No one else could do it for me. Hearing someone else say "Well, just trust that everything will be okay" was not the same as genuinely feeling it in my own heart. I didn't know that it would be okay. Even the words of well-meaning friends who said, "Just trust God" were simply words. I had to eventually reach the point where I could <u>feel</u> that trust within me. I guess it was something between God and me. God made a promise and was patient with me. He was right there to be trusted, ready for the journey…when I was ready.

Quieting your mind...

I like reading from the Psalms. There always seems to be a message that the writers wrote "just for me". For this moment in time, turn to Psalm 40: 1-5 and 16.

Think about the first verse: "I waited patiently for the Lord; he turned to me and heard my cry." There is no "maybe", no "I'll think about it" in God's response. Whatever that dark and slimy place might be in which we have found ourselves, God reaches out and sets us on a good solid piece of ground. And then – and this is really good – God puts a song in our heart. Indeed, we will see and experience the fear of the circumstance but we can trust in the promise God made to us. Once more...there is no promise of a life that will be problem free. The promise is that God can be trusted.

There are just so many blessings in what God has planned for us. God will pick us up, clean us off and fill our hearts with joy. Remember that promise and we can get through the deep water. Remember that promise and we can move through the dark. Remember that promise and we will find ourselves singing his praises!

Remembering and exploring your thoughts...

The Calendar page...

Trust me. There will be days when it just seems as though you don't know whom to trust. Your insurance company is balking at delays in payment. Their explanation is that company policies have changed. Sometimes the fine print gets pretty fine. Maybe your doctor assured you that a particular treatment would make a difference. We certainly can't all be trained in medical technology so you trusted the doctor's decision and now it doesn't seem to have the results for which you hoped. The company you work for promised that your job would be there until your health allowed you to return. Then, they discovered it was going to be longer than you expected and now someone new is sitting at your desk.

Here we are back to those fears and frustrations again. When doors seem to be closing, be assured, you can trust in God's plan. It is difficult to trust in what we can't see when what we do see seems to all point to bad news. God gives us reminders that he can be trusted. God uses people, experiences, maybe an article you read or a sermon you heard. Maybe it is the peace you feel while sitting alone, quietly listening to a gentle piece of music. These reminders might slip by, not recognized in the course of an ordinary day. So...use your calendar page to remember these gifts in each day.

When your neighbor suggests a call to someone knowledgeable about insurance and your company listens, put a note on your calendar. Someone else with a similar health concern tried the same treatment and did have good results. This person challenges you to stay with it just a bit longer and what do you know...slowly, you do begin to notice a difference. Put a note on your calendar. Someone asks if you might be able to assist with a project – working from your home. What a blessing! Put a big star on your calendar for that one!

Mark that day when God put an experience in your life that is a special or unique reminder of the promise he made to you that, indeed, you can trust in his plan...no matter how impossible things seem at the moment. Like Moses with all those Israelites complaining about

life with the Pharaoh! Like Moses who said "God, you want me to do what!" Like Moses when he heard God say, "Don't worry, you can trust me to hold the wall of water back. I have made a path for you to follow and you can trust me."

There will be dark days. There will be challenges. You will feel the fear with unknown situations. But God will hold the water back. There will be light in those dark days. Solutions will come out of the challenges and calm will overcome the fear…if we trust that God has a plan. We can use tangible reminders of his blessings. As they happen – make them a red-letter day! I have a feeling that your calendar page will become quite colorful!

Try this with me...

It is easy for me to go on my merry way and think how well I am doing. This may be the case but I do forget, more often than not, just why I am having a good day. What could you use so that when you see a particular object or image, your sense of awareness of your dependence on God automatically kicks in? I already have an image in place...a feather. It is kind of a long story, one that relates back to my experiences of treatment for breast cancer. To me, the story is quite amazing and maybe even a bit of a miracle. I'll be sharing it with you later in our visit.

A beautiful red cardinal shared that part of the journey with me and now the image of a feather, no matter how large or small, whatever the color, or in whatever kind of condition, always stops me in my tracks much like the child who noticed the small flower on the path.

It's usually just a simple feather, nothing magic about it. The image or the actual feather always alerts me to my sense of (or lack of) awareness. What's the message in the moment? A feather probably just floated free from some bird, falling quite by chance on my path. Or do you think that God just might have seen the casualness of my awareness and blew that feather just a bit more my direction? Who knows! I don't know the answer but it doesn't matter anyway. The feather has done its job. I have become aware of the moment or what is happening at that instance and I am listening. The fact that I recognize I have become more aware is what makes the moment of awareness the miracle.

Consider this – try to live in that awareness as frequently as you are able. Does recognizing this heightened sense of awareness begin to become a more natural part of your response to the blessings of the day?

Do the following...

Open your eyes.
Open your heart.

Freshen up your senses.

Smell the morning. Watch a sunrise or sunset. Look at the stars.

Open yourself to the awareness of what is happening each day.

How soft the towels feel as you take them from the dryer.

How soothing the hot water feels on your hands as you do the dishes.

Open yourself to a sense of peace, recognizing the blessings of the day.

Let go of the stress you brought home from work and set aside regrets.

Open yourself to the stillness of each new day, each new beginning and each new answer and then rest in the peacefulness of the evening. Become aware of what is happening around and within you. God is talking to you.

When a feather appears on my path, it becomes a moment when I feel God tapping me on my shoulder saying, "Wake up, my Child. Here is the gift I promised I'd give to you, right on your path."

So, consider if you would, what image you might choose. What image or object would cause your body, mind and spirit to pause and listen to what God is saying in that very moment?

There is a space on this page to draw a picture of the image you will choose to use. You might decide to cut and paste, on this page, a photograph from a magazine or even use a photograph you have taken yourself. Reminders are usually helpful and for me, a visual reminder is even a better choice.

One more thing...

Trust doesn't happen in the blink of an eye. As we grow and move through our life, our level of trust ebbs and wanes. That is natural. That was true for Moses as well. Some days Moses probably wished he was comfortable, back in that palace, passing off responsibilities to someone else. Who wouldn't!

Actually, he learned that he could do just that. Not really "pass them off in the comfort of the palace" but he could learn to give them up...and that took a bit of trusting, even for Moses. He needed to be reminded that he could trust that God would continually encourage and protect, challenge and guide. After all, there had been a promise made.

The trust Moses came to have didn't happen all at one time. As Moses progressed through each stage of experiences, there was a plan. Such incredible experiences – frogs and locusts, death, fear, questions, mountain-top joys, and deep valley disappointments. There were countless times Moses could do nothing but learn to trust God.

Take some time during these days to read Exodus 13: 21-22, Exodus 14: 19-20 and Exodus 14: 21-22. Also take a look at Isaiah 43. In verses 1-3a, it reads "Now this is what the Lord says, 'He who created you, O Jacob, he who formed you, O Israel: Fear not, for I have redeemed you; I have summoned you by name. You are mine. When you pass through the waters, I will be with you, and when you pass through the rivers, they will not sweep over you. When you walk through fire, you will not be burned; the flames will not set you ablaze. For I am the Lord, your God, the Holy One of Israel, your Savior." God goes on to say that we are precious and honored in his sight. When I read or hear those words, I know that I can put my trust in this God who calls me by name.

By day and by night, God provided what Moses needed. There was an angel leading at the front and another protecting at the rear. The sea parted until the people passed through. Read Exodus 15: 13,17 and 18. Moses sang. God's unfailing love led them. God will be there forever

and ever. In our humanness we need to be reminded that God's plan is to be trusted.

A prayer for trusting...

Lord, I don't know whether I could have stepped into the sea, between those walls of water, without you. You see, I am not a swimmer and I would have had a terrible knot in my stomach to think of doing such a thing.

Lord, help me focus on what you can do rather than on what I cannot do. Whether it is an illness, my job or family difficulties, each day we face an unknown. Find ways to remind me that you will separate the waters and lead me through. With your help I won't focus on my inabilities, but rather, your promise.

Lord, sometimes I need it all laid out in black and white. Forgive me for my lack of trust. Thank you for your patience. And thank you for making your plan clear when I find myself being a "show me" person.

Lord, thank you for being the God you are. I continue to trust you – each step of the way.
Amen and amen.

Section 4

And God blessed them and said...

You are becoming
the person
I created you to be.
Celebrate!

*And God blessed them and said...
"You are becoming the person I
created you to be. Celebrate!"*

Have you ever been just a little bit surprised when you looked into a mirror? Somehow, the person I imagine in my mind's eye isn't always the one looking back at me in the mirror. I have photographs of my mother and grandmother when they were about my age. I am beginning to see their features in my face. I have a past; physical characteristics, personality, behavior, etc., all parts of me that have been carried on for generations and generations…back to a beginning, somewhere, sometime.

God is such a "process" kind of God. As the creation story is described day by day, event by event, we are constantly being made aware of an on-going process in all that was created, right to the creation of humankind.

After all the days drew to a close, God acknowledged his accomplishments for the day and saw that they were good. And when that last day of creating came to a close, nowhere does the Bible say that God put away his tools and locked up the workshop. It just says, "God rested." He had plans to return to the drawing table and workbench. There were more plans to consider and more creating to be done.

We, God's people, God's children, are one of those "in-process" projects. We are all at different stages of completion. Every morning the day begins with new lives, fresh little people, waking up in a new world ready to be molded, polished and sent out to do what God challenges us to do. God has brought to life another tiny seed and a life begins to grow. Another piece of the process has begun.

Consider for a moment – something in nature, maybe. Think of something that you see on a daily basis. Maybe you visualize a big oak tree in your front yard or herbs growing in a plastic butter bowl on your windowsill; maybe you consider a lake in a park nearby or a left behind water puddle in your back yard. Now stop and think of all the changes that occur with that one space in the course of a week or a month or a year.

That oak tree in your yard… it might be covered with fresh green buds on a spring day and before you know it, brown leaves are falling to the ground. And those herbs – how can those tiny seeds growing in a butter bowl mature to be able to season an ordinary meal and make it a delicacy. The rains fall all day and the puddle in the backyard grows larger, preventing dry passage from the backdoor to the garage. And with just a day of sunshine, the muddy space has become crusty dry earth.

How many times we boated on the Ohio River and were in awe of a surface that was smooth as glass. Then, one morning driving to work, the fog had settled in so thick that it seemed the river didn't even exist. Amazing changes when you think about it. And that is just like us. Changing every day. Fresh with energy or feeling dried up. Peaceful or bogged down – all in the course of a day. Interesting.

God created more than my mind can begin to fathom and one of those pieces of his handiwork was humankind. I don't know just how it happened. I work with clay as a potter but I have never rolled the clay around in my hands to discover that I had created "Adam"! I am a student of art history and as I read about very early human accomplishments and artifacts that have been left behind from thousands of years ago I recognize that even these early people were created in the image of God. I don't know how God did it but I believe we are here simply because God did do it.

Somehow in this creative process he chose to create me in "his image". Now I don't think that means God looks like me or that I look like him in the way I resemble my mother and grandmother. I was made by God, somehow, "in his image". He told us that and I believe him. Some of the very same qualities of our God, the Creator, were transferred into my tiny seed as I began to grow and develop and have the potential to provide flavor to my world.

So, here I am and there you are – works in process. As a potter, I am very aware that the process for preparing the clay, throwing the shape on my wheel, trimming, decorating, firing and glazing all need to be developed in sequence and in a timely fashion…and with care.

Centering a "work of art" must be done with concentration and purpose. A haphazard effort will result in a haphazard finished product. If I were to leave that moist clay out in the open air for a day, unprotected, I would soon have a rock hard lump, a clay body impossible to mold. There are times I have become a bit impossible to mold. Have you ever felt a whole lot "dried up"?

Once that clay is spinning on my wheel, creating the form I want is just plain hard work. When I first began working with clay, centering the form on the wheel head was so very difficult for me. My husband gave me a gift of a book entitled Centering by M.C. Richards. It was about the centering experiences we need to master in order for our life plan to flow smoothly. In one short section, the author described the need for the potter and the clay to work together. Such an insight for my wheel throwing and life molding! I have often behaved as if I didn't need God as my potter and teacher. Somehow, seeming to be much like that sloppy lump of clay, I have figured I could do it all by myself. Take note…there is a message in that for us!

Slowly we take shape. Sure, sometimes it is hard work and the process gets messy. As the strong and sure hands of the potter pull up and push in and out on the clay, taking time to form and trim, a beautiful piece emerges. I've been over sixty years in the molding process. During those times when I felt without "form and void", how comforting it was to know God was in control, his hands around me. How comforting to be able to envision myself – much like I would do before I faced the mirror – as a beautiful child of God with a complete sense of worth in my whole being.

Even more miraculous was the thought of myself in God's hands, recognizing myself as being created in his image. Deep in my heart I could feel God saying, "Celebrate this person you are becoming. You are my hands in the world!" And I continue to grow in the process.

Quieting your mind...

There are so many characters in the Old and New Testament. Many were God fearing individuals, ready and willing to grow in the image of God. They were all in the "process" of becoming the person God had planned for them to be. It was hard work – building boats, walking across deserts, defeating armies and conquering giants.

There were sacrifices and surprises...Hannah bore Samuel after deeply desiring a son but she gave him back to God. Elizabeth and Sarah were no doubt surprised beyond our greatest imagining at the turn their lives took in their old age. Imagine what women of today would say about giving birth to children at the grand age of ninety! And Mary – what can we say. What a plan God had for her as he molded her all the way from the stable to the Cross.

God is still rejoicing as we grow into the people he planned for us to be. Such potential we have! Celebrate with him. The finished product will be more amazing than you could ever imagine.

Remembering and exploring your thoughts...

The Calendar page...

What if you were to focus on your own personal growth for just one week or a month or maybe throughout one season during the year. Consider your growth (or maybe lack of it) as you daily progress through this selected period of time.

Use a calendar with large spaces allowed for each day. Or you could make your own – or maybe you could keep your thoughts in the form of a small journal.

Consider several aspects of your being and select just one or maybe two. It might be helpful to develop a list at the beginning of your record keeping…what aspects of your personality will be the areas upon which you will reflect? Here are some suggestions:

Physical appearance: For instance - "I had a haircut today and I believe I look ten years younger" or "I weighed myself this morning and I actually lost a couple pounds".

Relationships: For instance - "I felt out of place at work today – like everyone was on the inside and I was left out" or "I sat down and shared some concerns with my friend today – insights for both of us".

My Creative Expression: For instance - "I decided the bathroom need some new life – some color - so I painted and it just cheered me up" or "I have found some answers by writing in my journal today".

Continue with personal goals, family experiences, etc. When the month is over, read back over your recorded thoughts and responses. Did the reflecting cause you to develop a deeper sense of awareness? Did this awareness lead to personal growth whether it was something about your physical appearance, your relationships or maybe in how you began to express yourself. Nothing is too small to consider "growth".

We all have days when nothing much happens but even in the quietness of such a day, did you have an awareness of a gentle nudge – waking you to something un-noticed. Awaken to the gift of each day. Learn to listen to the messages in each day, whether it comes to you as a whisper or a shout. We never stop growing. God never locks the workshop door. There is reason for a celebration in each day.

Try this with me...

This is one of those scissor and glue ideas. Don't close the book without considering the possibility of having some fun with this idea. You will need: scissors, glue, something to use for a background – about 18x24 (no smaller), old magazines, maybe some photographs that you can cut up, colored papers and markers. Paint, if you are really brave!

On a strip of paper – you decide the size – write/draw/paint the word "Celebrate"…as bold and beautiful as you can make it. This word will be the center of your finished product, the focal point of a collage.

For the first week, for instance, look through magazines and tear out images or words that tend to be descriptive of you. Even tear out sections of color that "describe" how you feel. Put the pieces in a spacious container such as a large envelope, a shoe box or a bag. Look through your collection, arranging and rearranging the pieces.

If you choose to work in time periods of a week, then during the second week find a place where you could put the background piece, leaving it out where you can get to it as needed. Is there a table in the basement or a corner in a workroom? Could you set up a card table in the guest bedroom? Would you like to paint the background or cover it with a large sheet of paper? Just as you would begin working with a puzzle, start by laying out all the pieces you have collected. Once again, arrange and rearrange the pieces but this time start to tell a "story" about yourself. Do some of the colors create a powerful expression with a certain image? Could a photograph be over-lapped by a line of words that relate to the picture? Don't begin gluing the pieces to the background yet. Continue to explore the design.

Now you are ready, probably during the third week, to seriously consider the completed work. When creating a collage, which is merely a collection of objects attached to a background surface, it is often helpful to work from the background forward. Try to cover most of the background space unless that empty space is part of your plan. Place everything where you think you would like it…study it for awhile and

then begin by pasting the pieces to the background, beginning with one section at time.

You just can't do a collage "wrong". Think about what it is that you want to say about yourself. Put your imaginary critic in another room and don't invite it back in! Be thoughtful. Have some fun. Reflect. Explore. When you complete the collage it just might be like "looking in the mirror"! What do you think of that?

One more thing...

Do you remember anyone ever telling you it was "just growing pains"? Growing isn't easy. Changes can be difficult and surprises are not always pleasant. Challenges can be frustrating and progress can be stressful. But we all do it...everyday. The important thing is that we don't grow on our own. The plant doesn't water itself nor does the puddle dry without the air and sun. We don't grow on our own.

In a society where we are challenged to stand on our own two feet and to pull ourselves up by our own bootstraps, we don't receive much encouragement to reach out for help. Let go of that thought for this month. Each day, remind yourself from your first moment each morning, that there is nothing you are going to do that day that you will do by yourself. The God who created you is going to be right there by your side. God isn't going to do it "for" you but he will be doing it "with" you.

Read the following verses and reflect on what they have to say about growth and change...and maybe a surprise or two:

Genesis 18: 10-15; I Samuel 3:5; Psalm 27:11; Psalm 37; Psalm 86:11; Psalm 100; Luke 1:11-14, 2:26-36 and Romans 8:28. Jot down those words that seem to especially speak to you. Read and re-read your thoughts as you move through these next days or maybe weeks.

Sit quietly and feel yourself being molded in God's hands. Clay in God's hands, spinning and whirling on his wheel. Shaped and trimmed, handles added and spouts attached and at the end, glazed and fired to perfection.

A prayer for growing...

Lord, how proud I am when I take my first step...all by myself. And I guess that really is an accomplishment. Often that first step is followed by a quick fall, right on my fanny. That, too, is part of the process.

Lord, how quick I am to step out on my own and how easy it is to lose my balance. Remind me that I don't have to either walk alone or try to get back up on my own. You are going to be right there whether I am walking or plopping.

Lord, give me courage and insight when I do both or either. I have to learn to walk in order to grow. I have to learn to accept change and challenges in order to grow. I have to learn about success and failure in order to grow.

But **Lord**, remind me that in change and challenge, walking or falling, you are right there with me. And you are there to celebrate with me when I break out in a full run. Isn't life great! Thanks for reminding me that I am the clay and that you are the potter.
Amen and amen.

Section 5

And God blessed them and said...

Have a Dream!

And God blessed them and said...
"Have a Dream!"

Can you imagine where we would be if there hadn't been someone out there, somewhere, over time who had a dream to make just one little change or improve one way of doing something! Don't you wonder if maybe, one day, God sat back and dreamed of all the possibilities with the space around him and thought, "I wonder what would happen if I did something with this dark and formless void?" One thing led to another...

I was trying to think back to my early dreams. My first wishes. My family lived on a farm in the country but I never wished I lived in town. Dreams weren't really practical in my family. Those kinds of thoughts were considered a waste of time. More like "day-dreaming". There was work to do.

I think one of my first dreams as a young college student might have been the image in my mind of playing piano at a beautiful lake resort, entertaining crowds of happy vacationers. Remember, living on a farm didn't allow time for "going to the lake" in the summer, an incredibly popular place in Minnesota. When the opportunity arose for a summer job of playing piano at a very popular resort, I jumped at it. My dream didn't move on the path I had planned. Instead, I was encouraged to remain on my college campus and work at improving my grades rather than improving my entertainment skills. There was just no other place

I had wanted to be than at that piano...I could just see myself on stage; my fingers flying and the crowd applauding. But do you know, as I think back it wasn't the dream of the resort and the piano, or even of the crowd...it was the total pleasure of knowing I was loved. That was the core of my dream. They loved me...in my dreams.

Isn't life amazing? We all simply want to be loved. In a million and one ways God has already told us, every day, "I love you" and yet I continue to dream of all the crowd pleasing experiences as I seek reinforcement of that important message. What a dream – simply living my life, hearing the applause, assuring me that I am loved.

We have been given a promise that the inner need to be loved can move beyond being just a dream. It's reality. God is watching me as I live my life. Sometimes God applauds so loudly that even others can hear his approval and then other times it is more like a wink of the eye...a quiet sign of approval. God does love me! If I change the emphasis, moving it from word to word, there is an awesome round of encouragement from my audience of one. GOD loves me. God LOVES me. God loves ME! The dream of being totally and unconditionally loved is now a reality. Then something remarkable happens. When I accept the reality of that dream, the door opens for a more confident kind of dreaming. God has nodded his approval and the possibilities are endless.

Dreams don't reach their fruition with me simply stretching out on a blanket, gazing up at the stars, wishing it would come true. Dreams require us to stand up, fold away that blanket and head for the drawing board. Mother Teresa could not have cared for countless numbers of people by simply "wishing" their bellies were full. Governments of countries will never lead us to peace by simply "wishing" that people could just get along with each other. Teachers will not guide their students to greater things by "wishing" they could read. Dreams that come to life require elbow grease and sweat on our brow. Dreams require walking the soles off our shoes. Dreams require mistakes and trying over again – and again. Dreams aren't satisfied to rest in our mind. Dreams call out to "get the show on the road!"

Interesting that the deep desire we all seem to have to be loved is met with no effort on our part except to receive that love with open arms. Sounds simple doesn't it but we can be really hardheaded about hearing that message and then believing it...but when we do – WOW!

We can hear God standing up on the seat of his chair shouting "Bravo! You can do it because I love you!"

Dreams open the door to exploring. Dreams are invitations to explore the reality of what, at the moment, is just the seed of a thought deep in our heart. Dreams open us to challenges. Exploring is not a passive activity. That's where your ideas lead you to getting your hands dirty!

Dreams can grow out of difficult life experiences. As I was recovering from chemotherapy and radiation treatments, I would dream of sharing the creative ideas that I used in order to move through these difficult times. I would dream of leading workshops and talking to people, creating together and encouraging them to write as they explored a devastating illness. As I rested on the sofa in my living room, how I wished I could be with a group of survivors – painting, writing, and sharing experiences.

I began to feel stronger and a more normal routine began to return. The wishes began to solidify into probable dreams and these dreams began to develop into actual plans. I read and researched what others had done. I wrote and I created. I worked hard. Some days it just didn't seem like it was going to go anywhere and other times I was excited at the possibilities.

And then the possibilities began to result in dates on my calendar... groups that asked if I would share my ideas with them. There were cancer support groups, physicians who worked with cancer survivors, church groups who wanted to learn more about supporting those living with cancer...but it was happening. One of the most thrilling experiences was being asked to be the keynote presenter at a celebration for survivors presented by a large city hospital. This was really me...sharing my story. And in the audience was my daughter who had been the rock throughout my cancer journey!

As I emptied my cart of "workshop tools" after that event I thought, "That was one of the most rewarding workshops I've had!" The dreams had become a reality. I have my notebooks, paint trays, journal samples and writing exercises. I have my stories and the participants have their stories. When I stop and listen, I can hear two very special hands, clapping, saying, "I told you that you could do it. Remember I love you!"

Our dreams don't develop with wishing and magic. Being reminded, maybe minute by minute, that God is applauding and shouting, "I love you!" gives us that confidence to explore the invitation to move forward. I wonder if a long time ago, when God began doing some dreaming of his own, if he maybe thought, "I can just picture this place with a bit more light, maybe some bright colors and growing things. And someone to enjoy it with me!" Do you think God might have pondered for eons and then said, "You know, I think I'll do it!" And he did. It must have been a lot of work. He stopped to rest but the creating continues. God has made us to be the energy, the hands and feet and the action, of his dream. Such an invitation to us! Such a lot of work we have to do! What a cup-filling challenge!

Dreams can set our hearts to racing. We can't wait to do something or tell someone. It might be the dream of a wildflower garden that finds us searching through seed catalogues in January. It could be a vacation that requires hours of planning before the departure date. It might be the dream of a first job, a wedding, a first house or the birth of a first child. It might be leading a group of children to success or leading a nation to prosperity.

Dreams don't always become a reality following our timeline. The dream might be incredible but the wait for it to become reality might seem endless. The dream might be the answer to everything you hoped for but the question remains "Why does it take so long?" Maybe it was that first job with so many resumes, applications, interviews and rejections or it could have been a marriage that brought changes, challenges and compromises. That perfect first house that had a "sold" sign on the lawn when you went back for a second look. My husband and I were married six years before our daughter was born. We had jobs and a house…and dreams but we still waited and waited for our family to grow.

God wants to be a participant, a playing partner, in our dreams. God knows the desire in our hearts. God knows our imaginations are on fire. But God also knows things that we don't know. He knows what is good for us and when it is good for us. God does offer the support and guidance we need to launch these dreams. God is the energy and the encouragement behind the desire we feel in our hearts. God does provide the courage to take the risks and the insight to make

the decisions. God does say, "Dream on, my Child. I love you, but remember to dream with me in your heart!"

I believe that God created people with a dream in his heart. We are created in his image so we, too, are created to be dreamers. God envisioned us caring for his earth, loving each other, living in peace and rejoicing in the blessings he has bestowed upon us. God is a worker. He created us in his image so we, too, are created to work at those desires of our heart. God has had to wait. Sometimes I wonder if maybe some of God's dreams didn't work quite as he hoped they would. God created us in his image, giving us the guidance and wisdom to live out our lives but we often seem to be working on our own timetable, not God's.

As people we have been stubborn and self-centered. We have been greedier and angrier than God had imagined. We have caused God more heartache than he could have imagined. But God keeps watching us as we simply live our lives. God continues to encourage us in our dreams (and his), applauding and reminding us that indeed, he continues to love us, even if we have caused a delay in his plans. That dream is still in God's heart because he loves us so deeply. With God's dream comes the invitation for us to have a dream. With our dream comes the invitation to explore the endless possibilities. Remember, fulfilling those dreams, exploring those ideas is a partnership.

Psalm 128: 1-2 reads "Blessed are those who fear the Lord and walk in his ways. You will eat the fruit of your labor, blessings and prosperity will be yours." Continue dreaming. Be diligent in creating plans to carry out those dreams but remember that the energy put toward the fulfillment of those dreams and the exciting results that might transpire come from the Lord who has blessed us.

Quieting your mind....

There is a plan. God is leading us along a journey to continue growing, becoming the person he dreams that we can be. He loves us deeply and encourages us continually. The invitation comes from God and is put into our hands. Our own dreams begin, piece by piece, to become reality. No magic. Lots of "get your hands dirty" work.

Be still today. God may applaud loudly but he also speaks with a quiet voice. When my world begins to sound like the clatter of daily responsibilities, loudly wearing away at my dreams, then it is time to be still. Sit alone, away from the clutter of life and be still. Listen. The invitation to dream and to explore is there.

Remembering and exploring your thoughts...

The Calendar page...

How many zillions of dreams have you had in your heart? I don't mean dreams in your sleep but rather dreams in your heart. Big, little, silly or practical, any kind of dreams. Do you "hear" yourself thinking, "You know, I wish…"

Here is an idea for you to do with your calendar close by. You might even need a larger calendar! Keep that calendar nearby so that you can make notes on it when these thoughts come into your mind.

Think about all aspects of your life – personal, health, private experiences, family situations, work, entertainment, and your spiritual life. When a thought comes up such as "I wish I weren't so tired" or "I wish the kids would…" or "I wish there was something exciting to do"…catch yourself. At that moment catch yourself and become aware of what is going through your mind.

When the awareness of such a "wish" jostles you a bit, write a large **W** on your calendar. That letter is going to be the symbol for a "**wish**" that has passed through your thoughts. That quick thought…that wish invites you to develop an all out dream.

Add a large letter **D** to that same calendar space. Now there is work to be done. The letter **D** will represent the **dream** you have in your heart. But…you are not going to let this dream just sit in the wish stages. So…add a large letter **E** for the **energy and exploring** you will need to move this dream to reality. Do you see why I thought you might need a larger calendar!

Allow me to give you an illustration to explain this process. Fibromyalgia is a chronic physical problem that will be with me the rest of my life. I am stiff and slow in the mornings and often it takes the morning to just get my body in good working order. This is frustrating! As I struggle with those first steps in the morning, I often find myself saying, "I wish I didn't hurt so much!" Wishing does nothing to put me on a healthier path. Wishing might lead to an "if only" kind of thought. How much better if I would have a morning plan…exercising, stretching, walking, so that my body functions with less pain. This

is a process, one step at a time, from wishing to doing…thinking to action.

Let's go back to your calendar. Imagine that here is a letter **W (wish)** in the space reserved for that day. Behind the letter make a note…"I wish I didn't feel so tired!" Maybe your mind has been too full of all that you need to be tending or maybe there are concerns that have overwhelmed you. We all certainly know what it feels like to be so tired we just don't want to take another step. Don't get stuck in the complaining stage when you could be moving on to a more productive state of mind. With that thought, move on to the letter **D (dream).** Considering that letter, close your eyes and create, in your mind, the dream that could lead to a solution. "I can picture myself full of energy, eager for the morning, and satisfied as the day ends." Wow! That's quite a dream. You could market the results of meeting that dream's goal and make a fortune! Realistic? Probably not but nevertheless, a good image to begin your plan.

So, give it a try. Being tired is no fun. What are you going to actually do about it…you know, no more just looking up at the stars. It's time to take action and do a little brainstorming. Behind the letter **E (energy and exploring)** begin to make a note or two for a plan. You might consider an exercise program or healthier eating. Could you manage a little more sleep or sharing your concerns with someone. Briefly jot that down on the calendar.

All of this is not going to happen overnight. Some days will be more profitable than others. You might find yourself more or less motivated depending on the day. Keep at it. Once again, the process is key. One step at a time.

Within this section, the Calendar Pages and Try this with me are going to be directly related so just keep reading…

Try this with me...

Get your journal out. Pulling dreams out of your heart requires some effort in the exploration and reality stages. It requires some brainstorming and some note taking. It's time to be still and reflective as you listen to the directions for a plan of action. This plan is a partnership. You are not flying off on your own. Remember that throughout the process and the results just might be more exciting than you ever imagined. A dream approached on your own is just like sticking a pin into an inflated balloon. It will burst before you even get the first plan in place. Dreams are meant to be the celebration of a collaborative effort. It will sound like an excited cheer, "WE did it!"

Keep your calendar handy. I recognize that we aren't going to be able to track every wish that pops into our minds but let's begin with those that seem to have the potential to make a difference in our lives. There might be so many wishes that some housecleaning is in order.

Remember the **W (wish)?** Stop and think. What is this wish all about? Write about the ideas that come into your mind. How did it first make an appearance? Was there a need or a problem? Maybe you experienced illness or emotional concerns. Walk with it as it leads you in the direction of where it all started and then take it by hand and let it lead you into your dream.

Then there is that **D (dream)** – what are you going to do with it? What does a solution to "I wish I weren't so tired" look like? What does having more energy feel like? Reflect possibly on a specific illness, the feeling of being overwhelmed, dealing with pain...consider those concerns that are foremost in your life at this moment. These are all very "real" experiences that definitely have the potential to lead to overwhelming fatigue.

What do you look like in your dream? I'm climbing mountains, swimming oceans and soaring through the sky like an eagle. Whoa! Reality is reality and that isn't reality! I don't think developing a plan to become a mountain climber or an Olympic swimmer will provide

any answers. Be still. Listen. Brainstorm. What will I look like if I put this plan into action.

Now comes the work. Write the words **energy and exploring** in your journal. No simple letters for this part of the plan. We want this right there up front and bold. How could this plan come about? If it were me, I might jot down some healthy eating ideas. When I come home from work, I tend to "snack". I figure if there is no one there to see me eat it, it doesn't have any calories! I think that needs a reality check! Maybe I could record my weight and then make a reasonable plan to help that number become smaller.

What about exercise? Research shows that even a walk around the block gets one's blood flowing. Think what would happen if I walked around two blocks and did it every day. I'm marching my way through my sixth decade...my exercise plan might not look like the plan of a twenty year old.

What about life situations? Are there things on my mind or in my heart that might be weighing me down, causing me to feel like I am carrying a sack of flour on my shoulders? (For you young people, my mother used to buy flour in a fifty pound sack and I would help carry it into the kitchen.) Emotional loads can be every bit as burdensome as those flour sacks!

What about your work or your family or other relationships? Do these experiences fill you with energy or maybe deplete your energy level? Don't think you are going to solve everything in one day...but begin to make a plan, one day at a time. Don't forget about the partnership. It will be easier to put that plan in place with God's help.

The **W**ish, the **D**ream, the **E**nergy and the plan to **E**xplore all begin to move the direction of becoming a reality. As you are brainstorming, contemplating, writing, reflecting and exploring...Stop! Take time to be still on a regular basis. You will hear a sound in your heart as you sit in the stillness. That's God's hands clapping together as he encourages you along this journey by saying, "You can do it, Partner. I love you!"

One more thing...

Read the Creation story in Genesis once again. What a dream. What fun God must have had, exploring, planning – and working. If God made us in his image, then he created us with a dream in our hearts, too.

Living in the blessings and joys of God's love is not a dream...it is a reality. Read Psalm 128: 1-2. Blessed are those who walk in his ways. A journey with your dream is not a journey on your own. We are blessed when we walk with God. We are blessed when we dream and explore with God. We are blessed when we partner with God. As that dream becomes an actuality, the blessings increase ten-fold and more.

Abraham and Moses, David and Daniel, the young Mary with her new baby or the Mary who was about to be stoned but was given a new life plan. So many invitations to participate in with God, seeing dreams become realities! So many times God has told his people, "You can do it because I love you."

A prayer for dreaming...

Lord, I seem to have no shortage when it comes to dreams. I'm even pretty good at exploring new ideas as to how these dreams can become a reality.

Lord, you know what I lack. I come up short on the action part. I tend to be a bit unrealistic and unreasonable in the expectations I have for myself. Could that be because I am running on ahead without you? For me, it is often the fear that my dream will fail and I quit before I even get started.

Lord, I also have a "hearing" problem. I spend more time listening to myself than I do to you. Remind me to be still and to slow down. I carry my briefcase home with me from work. I

clean house in the evening when I my day has already been full. I fill my calendar and then say, "I am so tired."

Lord, help me to walk in your ways as my wishes become dreams and the dreams become challenges to explore all the possibilities you have placed before me.

Lord, keep that sound of your applause ringing in my heart and remind me every minute of every day just how much you love me. I need to hear you say, "I knew you could do it! Remember, I love you."
Amen and amen.

From Psalm 17...

Listen to my cry
Listen to my prayer...
> *I call to you.*
> *Hear me.*

Keep me as the apple of your eye.
Hide me in the shadow of your wings.
> *I call to you.*
> *Hear me.*

You look into my heart and search my soul.
I have tried to stay on your path.
> *I call to you.*
> *Hear me.*

So many things call out to me, leading me where my feet are unsteady and where I am tempted and filled with fear.
> *I call to you.*
> *Hear me.*

God, you know my cry before it comes from my lips.
God, you know my heart before I awaken at dawn on a new day.
God, you protect me when the most frightening of life's experiences are at my door.
> *I can go to sleep at night and rest.*
> *Knowing that I am protected.*
> *Knowing that you listen.*

Section 6

And God blessed them and said...

you are created
in my image.

And God blessed them and said...
"You are created in my image."

When God described us as special creatures, "created in his image", he probably wasn't thinking that we looked just like him. What are those first words we often say as we gaze in awe at that fresh little newborn… "She sure has her mother's eyes" or "look at those long fingers, just like his father." God didn't really mean that we had blue eyes just like him or that we could look in the mirror and recognize a strong family resemblance.

There are times that I would like to see God's eyes and ears and feel his hands or touch his face. But that isn't how God works. In my line of thinking, God doesn't have a specific shape and form any more than we can determine the shape of the wind. God is as vast as the night-time sky and as complex as the constellations in that immense dark space. How can I even begin to make sense of God's words when he describes me as "created in his image"!

Think back to that newborn. I think those little creatures come to us straight from the heart of God, perfect as a spring morning, free as the wind, unique as the design of a snowflake and beautiful as the colors in the sunset. The love of his creation, the perfection of it all, was more than our creative God could contain in his heart. There was just one final touch to complete the world that was already so good.

With each day of hard work separating dry land and seas, filling oceans and growing vegetation, God was incredibly pleased with the results. Finally, when it was completed God scooped up the beauty and magnitude and awesomeness of what he had made, wrapped his love around it, breathed his love into it and here we are.

I will never forget the joy of holding our daughter just seconds after her birth. That amazing tiny baby – fingers and toes, beautiful eyes, arms and legs, a little head with no hair, cooing noises and baby smells. Can you imagine the overwhelming pleasure God must have experienced as he cradled each of us at our birth. I do believe God reached deep into his heart when he created us "in his image."

Just as much as I know God created us through his love, I believe God must look at each of us in our growing and developing and becoming. As God considers one of his offspring he might see the love of music, whistling, dancing to a tune, writing an opera or singing 'Happy Birthday'. God probably gazes at yet another of his children and sees the wisdom of a teacher, the healing skills of a doctor, the swift feet of a runner or the strong hands of a potter. God looks into the future and plans with the farmer or the politician, the mother or the writer.

Just as we see the potential in the eyes or hands or mind of that new little life in our arms, so God sees the potential in our lives. God created us with confidence, not confusion and so we are meant to live boldly, with confidence. God created us to say "yes" to his plans for us.

I received a new magazine in the mail yesterday and as I scanned it I read through the letter from the editor. In the letter was the story of a woman who had been a psychologist but after her experience with breast cancer she had set that career aside for a bit and had begun to explore the song in her heart.

Sounds familiar to me. I'm not rich, famous or well known but I recognized her need for a change in direction on her life journey. Somehow traumatic life events cause us to search deep within ourselves and often the gentle nudge to explore life becomes an outright push! Is there anyone who has not experienced some sort of difficult trauma that has reared its ugly head, causing challenges and fears that one can hardly dare imagine? I'd bet just about anything that once you had managed to move from that dark and probably frightening place, out into the light, there was, quietly and slowly, a new song growing in

your heart. Maybe that new song led you onto paths you never would have expected.

What if we really believed all of God's creation was "good" - ourselves included - right from our first breath? What if we admired our own creativity as much as we admire the sunset? What if we were as inspired in our own dreams as we are when we ponder the miracle of God's seven-day extravaganza of creating? What if we didn't need to wait for the trauma and challenges but cut right to the chase! My very creative Father says I resemble him. The song God put in my heart began to play as I gulped in my first breath of "earth air". Oh, what if we listened to that song as we opened our eyes to God's beautiful world! What if I dared dance to my own music, sing my own song before I ever considered lack of confidence, questioning, and fear. What if. What if. What if.

God didn't put his song in our hearts and then ask us to please turn down the volume. Don't wait for the dark to improve your hearing. Don't wait for tragedy to encourage you to challenge fear and hesitation. Look in the mirror today and see just how much you do resemble your Father.

What if you listened to the song God put in your heart and you began to explore the melody right now? What if you created a little dance to the tune or put words to the melody? We know for sure there will be difficult times but we must also remember to have some fun with life. We know that the music won't always be our favorite tune but play around with the notes. Maybe the tune is just fine but the instrument needs a bit of work. Go for it! That's what finding our hearts desire is all about. Listen. Don't let the song slip away from you!

Quieting your mind...

Before you quiet your thoughts open your mind for a moment or two. Think of explorers you might have read about in school. What must it have been like to sail down one side of Africa and back up the other, cautiously hugging the coastline, not knowing what the next bend in the continent would bring? What about crossing that giant body of water we call the Atlantic Ocean with no assurance there would be anything when you got there. Can you imagine walking to the edge of the Grand Canyon or maybe looking out a window at the Universe on the journey to the moon?

Totally breathtakingly awesome! Imagine discovering the song in our heart for the first time. Knock your socks off awesome!

Now be still and listen to the song that truly belongs to you... waiting to be discovered. Discovering the song God placed in your heart is every bit as exciting a discovery!

Remembering and exploring your thoughts...

The Calendar page...

As I considered topics for this particular book, I knew this section would especially touch my heart. How I love to create but how painfully difficult it is for me to see any worth in my work. I would like to be able to do as God did with the creation of each creature or river or mountain and say "That is so good!"

I tend to create and then carefully fold it up or pack it away. It is just so difficult to say with confidence, "It is good". In my youth I yearned to hear that what I did was "good". I lacked the confidence in my abilities and I wanted so much to be affirmed in my successes. And here I am... still waiting to hear that voice reassuring me that it is good.

Do you know what...? My hearing has failed me again! I am affirmed, as are you, in every single thing I do. God is that proud parent, hanging my work on his heavenly refrigerator door proclaiming, "Would you look at that!"

And do you know what I want you to do every day for maybe a month? I want you to listen. Some days the voice may be louder than other days but the voice is always there. The task on one particular day may be simpler than another day but the message you will hear from your Father is always the same..."Would you look at that!"

Do two things every day, possibly for a month. The first assignment is to listen. The second is to become a bit adventuresome. Explore "something" a bit each day. Begin the day with just a short prayer... "Lord, walk with me today." The adventure may be as small as trying a new recipe or taking a new path to work. It may be as simple as wearing something in a different color or listening to a new station on the radio. How many adventures can you record over time? Remember these with a note on your calendar. Remind yourself to listen for God's affirmation as you creatively explore just one note after another of the song he has put in your heart.

It's been said – do something a few times and it becomes yours. Let's try that this month. Maybe we will step into the next month singing a new song or at least learning the words to the song that has always been there!

Try this with me...

I can't explain how I feel when I am in my workroom. Actually, I believe we could turn the world around with scissors, glue, a little paint and some crayons. For you it might be fabric in a quilt or yarn on knitting needles. Well, I don't know if I can take on such a monumental task as changing the world but what if we could work a small miracle within ourselves.

My path to exploring is so simple for this activity...but it is a challenge. Begin in a simple way. Select a store with reasonable prices and consider spending no more than $10.00. Even if you are an accomplished artist, restrict yourself to this budget. (You could even consider using interesting supplies you might have around your house.)

But first...you are going on a shopping trip. As a suggestion, your first purchase might be a pad of paper. Be sure the surface of the paper can accept a water media in case you would like to use paint. Consider how much money you have left and then purchase a variety of art tools...crayons, markers, a simple water color tray which usually comes with a brush, maybe throw in some glitter or metallic gel pens. Whatever catches your eye and fits your limited budget! Oh, be sure to buy a bottle of glue in case you do some cutting and pasting. On the other hand, if you feel more excited using fabric or yarn, go for it! There is no limit to the possibilities. What if you even used the paint on your fabric or drew with markers on the quilt squares! Wow!

During this time you are going to explore that song in your heart! You probably have a pair of scissors. There are no specific directions. You are going to explore! Cut and paste images or words from a magazine, add crayon for color or draw with a marker for details, cut up newspapers and add color to the newspapers.

Maybe you chose fabric for a quilt or yarn for a shawl. Create a design or plan a pattern. Applique and add embellishments to the fabric! Could you even incorporate words that express a celebration while working on a quilt, for instance? Your completed piece could be just

the right size to fit on the front of a greeting card to a special person or it might be large enough to cover a wall!

Have fun! Just play! And as you play don't ever invite your critic to stop by for tea! For as many days as you choose, imagine your critic has left the planet. During this time you are going to experience a little adventure each day. Each day you are going to find a few minutes to play and each day you will say to yourself, "This is good!"

One more thing...

There are so many paths. Some are little more than beaten down grass while others are carefully designed and elegantly created. Some paths lead to unknown destinations while others are well marked. I remember the poem written by Robert Frost, describing the two paths separating in the woods. He chose the one less marked, a path to explore.

As I choose a path of adventure and exploration, I also make another choice. Read Psalm 128 and as you walk a path listen to God whispering in your ear or shouting in the wind. Listen to God's enthusiasm and satisfaction. "Blessed are those who walk in his ways." Listen for the song in your heart and don't walk alone.

A prayer for exploring...

Lord, how can I live in your world and not sense your excitement?

Lord, how can I live my life without paying attention to the song you put in my heart?

Lord, I want to feel your excitement and hear your music!

But Lord...I can only see the wonder of your creation and live with your enthusiasm flowing through me if I walk in your ways, staying on your path. Only then will I be able to say, "This is so very good."

Lord, keep me on your path, singing all the while.
Amen and amen.

Section 7

And God blessed them and said...

Take my hand
and join me
at my table.

And God blessed them and said...
"Take my hand and join me at my table."

I've been known to be a bit stubborn at times. I don't admit it to others but I usually do recognize the characteristics of this ornery behavior. An idea squirms its way into my head and the challenge is on...my way or no way! I may appear confident but stubbornness is just a cover up for frustration. It's what I do when I don't know what to do.

There were always friends and neighbors around the kitchen table when I was growing up on the farm. The men talked about farming and the women discussed gardening. The men discussed what to plant, how to plant and when to plant. Women were concerned about the best tomato plants, canning compared to freezing with just a bit of gossip thrown in for good measure.

It seems like folks are just too busy to sit down around the table these days, sharing good advice and maybe just a little gossip. Maybe it just seems more efficient to turn on the television and receive guidance from Oprah or Dr. Phil. There are shelves and shelves of self-help books in bookstores. (I have my share on my own bookshelves.) Sitting around the table just doesn't seem to be as popular in our current culture.

Guidance is such a comforting experience, allowing someone to take our hand and share our concerns. Don't you think we have all wandered through unfamiliar experiences, putting one stubborn foot

in front of the other? Can you remember someone extending a hand to lead you through the darkness of a cluttered path?

A long time ago God talked to a stubborn man on a mountain. Moses knew he wasn't about to do what God had in mind for him. If we could have been there we probably would have seen Moses firmly plant his stubborn, sandaled foot on the rugged rocky ground saying, "God, there's no way I can do it your way!"

God was not just dealing with one stubborn man. God also recognized a decidedly stubborn streak in his chosen people. God drafted Moses to lead his people out of bondage with a plan to guide them through a desert to some unknown land that God had selected for these very special people. Do you think we would have been much different! A promise to top all promises but the request from God to Moses sounds like no small task to me!

God recognized the stubbornness and extended his hand to both Moses and these downtrodden people. Such a four hundred years they had had in Egypt and this certainly didn't sound much better. God first assured Moses that he wouldn't be walking into this challenge alone and then God reassured the people that he would be taking Moses by the hand.

Even though we tend to be much like Moses and these wandering people, wanting to do things our way, God does take us by the hand, sets us down at his table and says, "How about if we talk this over." God knew some things these folks didn't know. God had a plan and offered guidance because he knew what was good for them. God guided them because he loved them. God still knows what is good for us and continues to love us enough to offer his hand to us.

Jesus worked closely with a small group of people and more than once he sat them down with the words "When are you going to understand?" or "Didn't I tell you this once before!" They would gather around a table, sit around a campfire or meet together on the hillside. Wherever they were, Jesus would guide them with some conversation or a simple story. Even those folks who sat at the feet of Jesus tended to fall back into their stubbornness, thinking they knew what was best. Just like the flocks of sheep that would wander away from the shepherd, Jesus would gather his friends together, put his arms around them and say, "Trust me, I know the way."

I've been one of those stubborn lost sheep more than once in my life. These have been times when I needed around the clock guidance. Some days I put on that old mask of self-confidence. So many times I have said, "Thanks anyway, God, but I'll just do it my way." Like Moses, I need support. I need someone to hold me up in the most difficult of times and quite possibly, even on good days.

It is in our strength that we are able to acknowledge the weakness and confusion we feel. It's then we open ourselves to God's guidance. Maybe Oprah does provide that "Aha" moment or maybe that self-help book does seem to lead us through the changes we need to make in our lives but there is something so very comforting about sitting right across the table with someone whom you know cares about you.

Seeing compassion in someone's eyes or hearing the concern in their voice – that's God's heart and hands there with you at the table. Guidance is about love, love that confidently takes you by the hand and says, "I know the way." How well I recall that guidance as I put my life in the hands of wise and caring people during my struggle with breast cancer.

When the task is unfamiliar or the path is unmarked and frightening, reach out to someone wise in God's eyes. When the answers don't come and life's problems seem unmanageable, seek guidance from someone with God's love in their heart. Open yourself to the guidance from that person God has placed on your path.

If we set our mind to it, I believe we could bring that kitchen table back into popularity again. I believe if we invited world leaders to the kitchen table there would be fewer wars. If nations solved problems around the kitchen table, maybe there would be less violence and hunger. Do you really think life has to be so complicated?

Do you freeze green beans or can them? Are you going to plant in April or May? Wouldn't life be easier if you stopped by my garden and shared some of your green bean experiences with me...good and bad alike. You might even invite me to your table for a taste of your infamous green bean casserole. Who knows – maybe one year you plant in April and the next year it is May. It just all depends on the rain.

God, open our hearts to your guidance in the most basic experiences of our lives. Help us grow wise in the simplest of things in order to be prepared for whatever crosses our path.

Could you use the space left blank at this point to do some thinking about kitchen table possibilities? Do you remember some times when you savored a long meal and delightful conversation with special friends around your table? Do you remember holidays when family members from the four corners of wherever sat and told stories and laughed together into the night? Do you remember kitchen table conversations that maybe were serious and somber as solutions were being sought for a difficult problem? Is your kitchen table still a significant focus in your home or has it become a place to collect clutter? Maybe it's time to sweep off the clutter and gather 'round.

Quieting your mind...

It's easy for a table to become cluttered. My bedside table has more books than I could probably read in a lifetime. My workroom table seems to never have any order to it. And the kitchen table – there is yesterday's paper, the mail, bills that need attention, and yes, even a couple more books.

Thoughtfully and mindfully clear the clutter from your table. When the business of your life has been removed from your table, sit quietly a moment.

Thoughtfully and mindfully do the same with the clutter in your heart and mind. Gather it together and place it on the Lord's table. He will tend to it. Join hands around that table and thank the Lord for stretching his hand out to you.

Remembering and exploring your thoughts...

The Calendar page...

It's one thing to experience God's hand in your own life and quite another thing to create opportunities for others to feel God working through you as you reach out to them. Think with me, if you would, about your kitchen table. What if you selected a specific period of time and then made a conscious effort to invite people to join you at your table.

I can hear you already – "but my kitchen is too small" or "I'm really not up to cooking for others." This isn't about fancy kitchens or gourmet meals. This is about reaching out to someone in a very comfortable way. You don't need to provide a counseling session or turn someone's life around. You are "simply" going to funnel some of God's love, through you, to them around your kitchen table.

Be a little creative. Here are some "what if's" to consider...
- Check with your area high school and invite an international student to dinner.
- Consider "singles" (young or old) at your church – maybe brunch on a Sunday morning.
- Do you have children? Work on a craft with them, make cookies or make your own pizza.
- Do your parents or your grown children live nearby? Get out the good dishes and remind them they are special.
- The lady across the street, the man whose wife died, the couple that just moved to town – invite them over even if you are just having leftovers.
- And on and on. The possibilities are endless.

BUT remember this isn't about your fabulous cooking or your designer kitchen. You are probably thinking "Thank Goodness!" because neither fit your style! BUT anybody's style could be made to fit the caring that can happen around a kitchen table. Anybody's style can be designed to fit the warmth of being loved and feeling guided. How might you plan a creative way to commemorate a special "table time" on your calendar? Get out the good dishes or make it potluck but don't miss the opportunity to simply discuss when to plant or how to preserve... just chatting around the table.

Try this with me...

We have moved into new days and our thoughts have turned to love, fellowship and caring for each other as we comfortably sit together around the table. Coming to the table is a sacred experience. The idea of coming to the table brings the feeling of comfort and support to one's heart. Coming to, being invited or maybe led to the table caused me to think of being fed.

Coming to the table, whether it is the Lord's table or our own table, is special, indeed. During this period of time our creative adventure is focused on making the "table experience" truly special. Since I don't know you well, you are going to do some choosing as to what your creative process will be.

Think about the table around which you will gather for some sacred time. As a cook, maybe this will be a time to plan some delicious dishes to set before you and your companions. Maybe you aren't a cook and decide it's time to expand your kitchen skills.

Rather than sharing a meal, it might be a time to plant herbs or flower seeds. As you watch the green shoots work their way through the rich dark soil, consider your own growth. The herbs might eventually add flavor to a meal you prepare further on down the road or the flowers might add beauty to your table. I'm a potter and I thoroughly enjoy using my pots and bowls on my table. Even as I write these words I can bring to mind the feel of that wet clay in my hands. A beautiful clay pot with some wildflowers in it would give me great pleasure as I consider decorating my table.

God takes our hand and issues an invitation. He loves us enough to repeatedly invite us to his table. Our thought is to spend some time considering how to enhance the sacredness of your table.

As you enjoy the choices you make regarding your table, think of the Lord's table. Maybe your baking leads to a loaf of bread for Holy Communion, the Lord's supper, or maybe those seeds in the garden produce flowers for the alter.

Remember – take time – and enjoy your table experience.

One more thing...

Think about preparing your table for the guests you have chosen to join you. It might be a holiday feast or a quick cup of coffee. In Scandinavian northern Minnesota where I grew up folks lingered long at the table, sipping on their coffee and discussing life in general.

Read Psalm 23, especially verse 5. "You prepare a table before us, in the presence of our enemies. You anoint my head with oil; my cup overflows." As we are surrounded by concerns, troubles and dangers, a challenging economy, these are the times God invites us to his table to fill us to overflowing and to protect us.

Listen carefully for the Lord's invitation to his table.

A prayer for the table...

Lord, I love the kitchen table. It does become cluttered but I know you can clear away some of the concerns that settle there.

Lord, I often come to the table hungry. Help me to be aware when the emptiness is caused by my choice to keep my cup empty.

Lord, I need to be filled – daily. As I sit at my table, alone or with others, fill my cup to overflowing.

Lord, you promised your table would be a place of safety. Reach out your hand to me when troubles are overwhelming. Make room for me at your table.
Amen and amen.

Section 8

And God blessed them and said...

Slow down!

You're running ahead of me.

And God blessed them and said...
"Slow down! You're running ahead of me!"

I can't imagine how long God must have been working, planning and creating this amazing planet on which we live...and all the worlds beyond. Deserts and oceans, mountains and canyons. So often I begin a task and I want it completed yesterday! Not only do I want it completed yesterday but it's good if it comes out perfect the first time. Now that sounds reasonable, doesn't it?

When was it we first heard the term "stress" used to describe challenging personal experiences? There is nothing wrong with working hard or hard work. Approaching both with common sense is probably quite healthy. I might sound a bit old fashioned but did you notice I used the phrase "common sense"?

Common sense and stress seem to be on opposite ends of the balance of hard work. My father was a farmer before equipment looked like machines from outer space. He worked hard basically because it was hard work. Even on those days when it was critical that some task needed to be completed, he reserved time for a nap at noon. If he had come home for lunch, he would stretch out on the floor just off the living room and would immediately fall asleep. If he was harvesting, hot and dirty from the grain dust, he just napped on the stubble in the field following the lunch that my mother brought out to him. Once again, he

immediately fell asleep. He worked hard but he knew the importance of rest.

My father also knew what he could control and what was out of his hands. It was up to him to keep the weeds in line but he also knew that dark rolling storm clouds meant it was time to turn the tractor toward home. Weeds he could manage but the weather was out of his hands.

As God's chosen people we have become confused as to who is really in charge. The path we have chosen has led us far from God's intent. I grew up on the Minnesota farm and I remember the pleasure of the south wind in early spring. I can still see the sunflowers turning their heads as the day passed from morning to afternoon. The smell of an on-coming rain takes me back to Minnesota rain storms and being truly awestruck by lightening as it flashed across that spacious sky. There is no doubt about who is in charge when one pauses to consider nature.

After having grown up on a farm, more than once I have been amazed that many of us have chosen to awaken to an alarm clock rather than the birds at sunrise. I have chosen rush hour traffic rather than the county road to town. I have chosen to be awed by promotions and paychecks rather than sunsets. Indeed, I have paid a price for prosperity. How could I possibly choose sitting in traffic rather than picking vegetables from the lush black soil of my garden. "Get real," you say, "You can't pay bills from the harvest of your garden or the warm feeling after watching the sun go down in the west." And you are right but as I reflect on my busy life, I am reminded of the risks that accompany my daily stress.

Like my father, I learned a great deal about what I could manage and what was out of my hands. My experiences didn't come while on the seat of the tractor but rather while I was sitting in the big hospital chair watching the red juice in my chemo bags slowly drip into my veins.

My life had been busy when I discovered cancer was going to make some changes in my daily schedule. I had been accustomed to going to work, taking care of my responsibilities there and then coming home to the tasks of maintaining a home as well as schoolwork for the next day. As a teacher, I usually brought some work home each night. I went to bed exhausted and was up by 5 a.m. ready to do it all over again. Sound familiar?

There were so many worldly concerns filling my mind. Picture it something like this… it was as though I was traveling over the speed limit without a road map, going someplace that I wasn't sure of and was about to run out of gas. Others who have been touched by cancer have described the days prior to their diagnosis in the same way. And here I am, about to share with you the blessings of the walk with breast cancer. What kind of a blessing could there be in losing a part of my body and then choosing to drip poison into my veins and being subjected to radiation. The blessing was that now I was walking at a much slower pace with God by my side. I wasn't running miles ahead of him. Slowly I was learning that I had to turn this over to God. Eventually I began to sort out my life and began to consider the priorities. I learned that God's invitation to work by the calm waters was much healthier than charging on ahead on my own. Slowly, it became a journey on a path with God instead of running ahead.

I do need to pay bills and buy groceries just like everyone else. There is still a house with a mortgage and needs for maintenance and upkeep. My husband and I still deal with a full calendar. Even though I am now retired, I still have many responsibilities and still find driving in traffic stressful. So what's different? My priorities and my sense of awareness are what makes this different!

When I drive to a nearby city, I don't have to choose to use the busiest highway in the state. My house looks nice and generally the laundry is done but I'm not obsessed with perfection. My work did take me a new direction following my recovery from cancer and it is interesting that I chose a direction with much less stress and one that I truly came to enjoy. Why does it take a catastrophic experience to cause us to slow down? Why does the need for just a little more money or prestige cause us to choose to work more hours behind a desk? Why do we ignore that pain in our stomach, ache in our back or pounding in our head?

I do need to have some sort of consistent income but my work, even in retirement, now fills me rather than consumes me. I like a clean house but now when I work through my tasks I choose those things that matter at the moment rather than feeling overwhelmed. There still are responsibilities but I have become wiser. God didn't dump cancer on me to teach me a lesson. Rather, he became my partner to walk with me

through all trying times. God didn't remove the challenges. He taught me to ask for help. God didn't promise perfect health but he taught me how to pay attention to what it is that keeps me healthy. I can take a nap without feeling guilty and usually get a good night's rest.

No, I didn't become perfect. I became more aware of all the debris in my life. No, I am not stress free but I experience a greater sense of peace and I am not running out ahead of God's plan for me. And yes, when someone says, "I just learned that the lump is malignant" I do feel my own heart do a flip-flop. There just might be a stray cancer cell floating around in my body waiting to manifest itself. God didn't promise perfect health but he did promise comfort, guidance, wisdom and an open hand.

So what's my role – when my head, heart and mind, tense shoulders and a stiff back remind me of the daily reality of stress? My responsibility is to put my hand in God's hand. I just don't need to run ahead, alone, getting nowhere. Slow down. We don't need to be out there running ahead of God.

Quieting your mind...

In the previous session I suggested that you quiet your mind by "opening" it. This time I am going to ask you to rest your mind by letting everything just melt to nothing. Close your eyes and let one specific stressful thought just ooze out through your skin, from your fingertips and your toes. Let it roll off your shoulders and down your back.

Just for a minute, close your eyes and let one piece of that concern leave your body. Watch it soak into the earth beneath your feet. Gone. Open your eyes. Breathe.

Do this throughout the day. Don't be afraid of becoming light as a feather.

Remembering and exploring your thoughts...

The Calendar page...

Remember, we have been pondering the dangers of running ahead, traveling alone and arriving exhausted...and having gained nothing when we finally get there. It's a sign of our times, I guess, but do you know that we don't have to choose the path that leads to exhaustion. It's just not healthy! So, instead we are going to consider caring for ourselves which is extremely important, don't you think? If I'm not feeling good or if I'm not strong in my heart, mind and soul then I won't be worth my oats for anyone else either.

You are probably living quite responsibly – going to your workplace, tending to your family (children or parents), maintaining your home, growing in your spiritual life and saving a bit of time for something fun. That list can go on and on.

As good and worthwhile and necessary as all those items on the list can be, they all consume your energy. Some items might carry with them higher levels of stress. It could be pressure to meet deadlines, problems with a child or an aging parent. You might be the queen of committees. Stress can even come from worthwhile projects or legitimate responsibilities.

Stress meets us head on when we run on ahead, traveling alone, arriving empty and tired. How will I get it all done! What can be left until tomorrow or can I whittle one or two items off my list? Where does one even begin when it is impossible to see the path for all the clutter?

During the next days, revisit the following exercise frequently. Find a quiet place. Use a strip of cardstock paper, about 2 inches wide and the length of a standard sheet of paper. Determine one end of that strip to represent high stress and the opposite end, lower level stress. Be still and for a moment, look from one end of the strip of paper to the other end. With the strip of paper placed horizontally before you, consider some of those things we listed earlier...the daily pieces of your life.

Choose one. Let's say your work. Give your job a two or three word description and determine where it fits on this horizontal strip. Jot it down on that piece of paper. Where would you mark the responsibilities

of driving the kids to all their activities and helping with their homework? What about the concerns of checking in on your aging parents or even just making a telephone call to them? It's painful to watch them become more dependent on others. You might even consider colored markers to represent various levels of stress. A suggestion might be to use red for the most stressful and maybe blue for the least.

You're right...all of it is important stuff. So important that it is easy to run on ahead, doing it all yourself and arriving at the end of the day bone tired and mind weary. Look at that strip of paper again and add additional significant responsibilities in your life. Is that narrow strip of paper becoming too full to even note those things happening in your life? A warning! Don't add more frustration to your life by thinking you can change everything all at once, just by marking them on that strip of paper.

Now consider all the marks you have made. If you chose to use color, are there more red marks than blue? Look over the marks and choose one. Chose this situation or responsibility carefully and then slowly analyze it. For instance, your son seems to be so quiet at home, pretty much tending to himself in his room. Then, one day his teacher calls and shares a significant discipline concern with you. Or maybe you are the caregiver for an aging parent. You have long recognized that mom or dad no longer is functioning well living alone. It is so difficult to bring up these life changes to an aging parent. Both would most certainly result in a red mark on the high stress end of that paper strip.

Discuss the situation with your family, if this is appropriate. Reflect on it in your journal. Sleep on it. Pray about it. Who is involved? What are you doing? Why? Are you inviting help or are you working alone? Why? Do you feel satisfied or cranky and tired? Why? Do you want to make some changes? How? Why? When?

One thing at a time. Look at the thoughts you shared on that strip. Begin where you are experiencing the greatest challenge, one item, one step, one day, at a time. Expect a miracle but not all at once. Listen carefully once more. Accept the gift of a solution because now you are running with a partner. God planned for you to be a worker but he didn't plan for you to do it alone. Accept the insight you receive as a gift...both from those people who are working with you as a support

system as well as a gift from God, who has quite probably put those people on your path.

Are there a couple minutes each day where you can set aside time to walk by the still waters? Don't go there alone. Don't rush. Allow yourself to be led. As you put yourself in God's hands you will feel your heart becoming lighter, your mind clearer and your soul more peaceful. Breathe deeply. Be open. Be willing to walk with God, not ahead, on this piece of your journey.

Try this with me...

The calendar pages for Chapter 8 and 9 are similar, as will be this section that we explore together. Chapter 8 found you in an interesting shop purchasing some basic art materials. We are out and about again today. Might there be a certain unique place that is relaxing for you... relaxing and enjoyable?

Our daughter surprised me with a "vacation day" for my birthday. We spent the day together simply enjoying ourselves. Notice the word "simply" enjoying our time together. I put a double meaning on that word. We chose such ordinary things to do together that day. We had nothing more on our agenda than to simply have fun together.

One stop was a visit to a large bookstore that we both thoroughly enjoy. It's one of those with the coffee bar and the huge overstuffed sofas and all the shelves of bargain books. We both just wandered from one section to another. I had an armful of books when I finally noticed a comfortable sofa by a sunny window. I paged through a book of maps with beautiful photographs of sites all around the world. Another book was about the night sky and how to use a telescope. We just had a pleasant time browsing.

Go away sometime this month. Take an hour vacation or a day vacation. Browse. Don't buy. If you start "shopping" you are back on the path of creating the potential for stress. It's not about spending money, waiting in lines, or making an item fit in your budget.

Just browse. Take only pleasurable moments with you. Smile in your heart. Do something "simply pleasurable" whenever you can or whenever the need arises. Try the library, a walk in the park, a plant nursery, the local art museum, a music store...whatever fills your cup and relaxes your mind. Just be quietly joy-filled finding pleasure in the moment.

One more thing...

Jesus had such a handle on knowing when he needed to be away from the crowds. How easy it would have been to perch his ego on his shoulders and race out ahead of everyone shouting, "Look at me. I can do it all."

Jesus "did it all" simply because he is Jesus. Because he reached out to others in every direction, he needed to rest. That same Jesus continues to reach out to you – simply because that's what he does.

"Come to me, all you who are weary and burdened and I will give you rest." Matthew 11: 28. Send an RSVP that says "Thanks. I needed that!" Such a comforting invitation.

A prayer for slowing down...

Lord…slow me down. I'm the Queen of the Fast Lane. Please give me a long red light.

Lord…slow me down. I think I'm the solution to everyone's needs. Remind me that that's your job.

Lord…slow me down. I behave as though I'm in the prime of my young years. Encourage me to dump my guilt when I feel the need to rest before the summer sky is even dark.

Lord…slow me down. There are so many simple pleasures in the day. Teach me how to fill my soul with your pleasurable blessings.

And Lord…be with me in my rest.
Amen and amen.

Lord, you made a promise to me…

that you will listen when I call out to you.

Lord, you made a promise to me…

that when there are so many things on my mind and I can carry them by myself you will be there to help me share the load.

Lord, you made a promise to me…

that when I am tempted by all those things that surround me in my world, when I find myself thinking of all that is not good for me, you will give me some "Godly attention".

Lord, I will make a promise to you…

but sometimes I have a difficult time in keeping my promises. I will give my heart to you. I will be quiet and will listen for those messages you have for me. When I fall asleep at night, I know your love is still with me and, with that in my heart I will sleep well – waking to another new day with you.

Section 9

And God blessed them and said...

I'm giving you a
New Beginning.

And God blessed them and said...
"I'm giving you a new beginning."

When I stop and think back on my life, there are so many experiences that could be described as new beginnings. There have been experiences when I truly felt hopeful even after spending long and frightening days feeling as though I was in a very deep dark place. When the very essence of life seems to be challenged in some way or another, the promises that come with the gift of hope do offer amazing new beginnings.

It wasn't too long ago that people were very hesitant to use the "c" word when they were speaking of cancer. I cannot recall the name of one single person whom I would have known in my hometown community who experienced any type of cancer. I guess maybe people just didn't talk about it. The discovery of a malignant tumor years ago frequently meant imminent death. There have been so many advancements in medicine just in my lifetime.

I was born in 1944 and, over the years, I had no occasion to become intimate with this dreaded disease. In 1996 that all changed. It had been a routine examination with an anything but routine outcome. "I'm sorry but the tumor is malignant," the surgeon who performed the biopsy told me. At the age of 52, I had to pause a second to reflect on the word "malignant". When I processed what that meant and the thought settled in my mind, the tears spilled over and I cried. At that moment, feeling desperate and so vulnerable, all I could think was that it seemed so "hope-less". I was totally without a sense of hope as I began a long journey with breast cancer.

Hope can be yanked away from you during the time of critical illness. It is tests and x-rays, conversations and decisions. It is statistics and thinking ahead. It is a spiritual matter and a financial matter. When hope seems unreachable in a difficult situation, each one of these experiences can seem quite overwhelming.

Hope might seem to be dangled in front of us in the time of critical illness. "This or that medication has been known to have good results," the doctor reports. Sounds hopeful but oh, how my body ached from the medication that was used to help increase the white blood cells after each session of chemotherapy. "That is such a wonderful wig! No one will ever know it isn't your own hair!" the nurse told me as we commiserated over the side effects of the chemotherapy. She didn't know what a traumatic experience it was to awaken one morning with my hair on the pillow rather than on my head. And then there was the experience of having the prosthesis fitted. Oh, how I missed being "me." I knew why no one wanted to talk about cancer. Neither did I!

One afternoon, during the days when I was healing from my mastectomy, I stopped by the high school where I taught. My left arm felt like it was absolutely useless. I could barely raise it away from my side. As I was visiting in the teacher's lounge, a teacher I knew only casually stopped right in the middle of what she was doing and raised her arm high in the air. It seemed that she almost touched the ceiling and then she looked at me and said, "I do know how you feel and soon you will be able to raise your arm to the sky. I know! I've been there." An unexplainable surge of hope rushed through me. Hope!

In those early days of recovery I received so many cards. There were even cards from people I didn't know! One especially. I remember opening the cards and reading the messages but it was the short, handwritten note in one card that filled by heart with hope. The note was from a prominent woman in the community, someone I knew only by reputation. She had taken the time to send the following message, "I, too, am a breast cancer survivor. It's been 32 years!" At that point, that was all I needed! Reading that affirmation from someone who could honestly say "I know how you feel" provided another surge of hope. Reading those words from someone who had been on the same journey gave me as much reassurance as my doctor's report of progress.

Hope seems to shine brightest when the experience at hand is the darkest. Having had the opportunity to be reminded of that, I would like to change my concept of hope. What about this! Wouldn't it be wonderful

to awaken each morning, on just a normal, everyday morning, to that same joyfulness and peacefulness that comes with a heart filled with hope.

Do I need horrific headlines in the newspaper or ominous warnings on the evening news to remind me of the hope that our Lord has promised? Do I need to experience calamities and disasters, illness and pain to be reminded of the secure hope there is in God's love? Do I need to experience the worst to be reminded of the truth of God's best…the unconditional promise of hope…each day of my life?

We might live in a modern world with more conveniences than we could ever imagine but our hearts aren't much different than the hearts of those people who walked through the desert with Moses or who sat on the hillside with Jesus. Their hearts ached for assurance from God that life was going to be better. Was the longing in Sarah's heart for a child really any different than that of any young couple today who deeply long for a child! Lord, give them hope that your plan is always in our best interest. As young men were fighting on the battlefields during Old Testament times, do you think those parents were any less hopeful that those brave warriors would return home safely than concerned parents of soldiers today?

We recognize and long for hope as we pass through dark valleys. Indeed, God has promised that we can be assured that there is hope for those difficult times. But…what if we were to awaken each morning with our hearts just bursting with hope! Each morning! Just because we woke up one more morning!

Hope is to desire something with confident expectation of its fulfillment. I'm going to add "sincere" desire to that definition. Some of my expectations for hope seem pretty fluffy. "Oh, I hope it won't be so hot today!" "I hope I remembered to feed the cat before I left." I suppose to the construction worker in the hot sun or the hungry cat waiting to be fed, both are real hopes but you get the idea. Hope is one of those overworked words.

What if we began the day, conscious of a sincere desire for every step of our day to be filled to overflowing with a confident expectation of fulfillment? Would it make a difference in my day? Would it affect what I do for myself or what I do for others? Would it make a difference in my attitude at work or with my family? Would I approach even the smallest pieces of my day with confidence, knowing that the God of hope will fill me as it is stated in Romans 15:13? Hope is as strong in the light as in the dark. I just need to improve my perception of hope.

Quieting your mind...

We have all been in the dark valleys of life. Illness, fears, concerns or trials are a part of our human condition. We've all lived through these experiences. God provided the security of hope for Abraham as he waited for an heir; God promised the security of hope for Moses when the land of milk and honey seem to be an impossible destination; hope for David and the prophets and the people who waited for the Messiah. God never failed them. God won't fail us either.

Begin this morning in quiet confidence that God's promise of hope will be fulfilled. Move through the day, tending to your responsibilities and enjoying the pleasures confident in the knowledge of God's presence in your life. End your day anchored in the hope of God's promise that he is the fulfillment of all our expectations.

Remembering and exploring your thoughts...

The Calendar page...

I presented some "what ifs" in the previous section and I am going to continue with another "what if". What if you consider a personal hope and the hope of another person in the days ahead. It's a plan for receiving and sharing with confidence the hope that we desire in our search for fulfillment during challenging expectations.

Where do I even begin with sharing examples of our expectations? Start with a hope focused on your own self. It might ultimately affect others but basically it is for you. I'll pull one out of the hat as an example to which I can relate. How about "losing weight?"

How many times would I casually hope that losing a few pounds would just happen? I hope I can find some recipes that will make a difference in how I eat; I hope these healthy groceries do the trick; I hope my clothes size will go down by my birthday. I hope. I hope. I hope.

Now...be deeply sincere and completely confident. Envision the expectation as a reality, not just a dream or a wish. Sincere desire and confident expectation help provide the strength, direction and realization that God promises fulfillment. Not easy answers or instant success, but hope. Not magic that the pounds will fall off but hope that if I really work at it, it can happen.

At the same time, could you be a gift of hope to someone else? You are not to set out as the answer to all their needs but rather to be the bearer of the gift of hope. I would think that gift could be wrapped in encouragement and support. Maybe visits and phone calls, a home cooked meal or help with the kids. Real and practical signs that someone else cares!

And I am hopeful this morning. Confidently hopeful that God is in control of our lives and the world in which we live. I am hopeful this morning that God's blessings will continue to fill my heart and fill the hearts of people in all corners of this troubled world. Indeed, I am sincerely confident that God's love will be the fulfillment of our hope and the hope of all those who share this planet with us.

Try this with me...

This is personal and specific...and very practical. Before this day is over, my guess is that you will have said, at least once, "I hope this works!" Hang on to that! Whatever "this" might be, get a handle on your confident expectations and a picture of what fulfillment might look like to you.

My work had been challenging as I implemented the requirements of writing the proposal for a grant. The writing of that grant was difficult but nothing compared to actually implementing the projects that I described in the grant. A dozen times during the course of the day I found myself saying, "I hope this works!"

We all put significant planning into the work that we do – but only effort and energy, creativity and support will actually bring those plans to fruition. Each time I casually or desperately say "I hope this works!" remind yourself that the fulfillment of your hope is in the Lord's hands. I often need a reminder – something between God and myself so that my casual hope can become a confident expectation.

The walls in my work space are such that I can easily hang objects near my desk. Could you find a place to hang something? Maybe there is a windowsill or a desk- top that could hold just one more thing.

If you think back to early sections of this book, I explained the symbolism of a feather in my post-cancer years. I'm going to bring up that feather once again and combine it with strong words of encouragement and support. Maybe the words of Hebrews 6, beginning with verse 13 will offer some solid support for you. Here we are once again reminded of God's promise to his people. Maybe it's something your mother said to you as she sent you off on your day's journey. It might be words of wisdom from a prophet, a poet or a philosopher or maybe the farmer down the road.

Find, or create, a blank card...blank on the outside and blank on the inside. On the outside glue the symbol you have chosen. It might be the actual object (such as my example of a feather) or an image representing that symbol. I also have a favorite photograph of a quiet water scene

that comes to mind as a possible symbol. Put this image or object on the outside of the card. One glance at it will remind you of confident expectations of God's fulfillment.

But...some days need a stronger reminder. Write a message you have chosen that relates to hope. When the image needs some added help – open the card. By actually opening the card, you are consciously recognizing the action it takes to "refill" your heart with hope.

Just choose one experience on which to focus at one given time in the day. Give it all you have and be open to all God has to give! Be bold with your sincere desire to feel more hopeful. Be confident in your expectations. Know that God is behind the fulfillment! Remember... In all things, have hope.

One more thing...

If you have a New Testament handy, open it to Hebrews 6, beginning with verse 17. Read it…and then read it again. Read it in the morning as you hope you can get through the day. Write the words on a card and carry them with you. Go to sleep with the words in your head, heart and soul.

Hebrews 6: beginning with verse 17…Because God wanted to make the unchanging nature of what was promised very clear to his heirs, he confirmed it with an oath. God did this so that, even today, we who have fled (gone off to do our own thing) can take hold of hope offered to us. In this promise we can be greatly encouraged. We have this hope as an anchor for the soul, firm and secure.

Read it again.

A prayer for hope...

> **Lord**…I'm so casual about the blessings in my life and often overwhelmed by the challenges.
>
> **Lord**…help me remember you are my hope in both the blessings and the challenges.
>
> **Lord**…join me in my boat as I sail thoughtfully through calm waters and stormy seas, reminding me constantly that you are my hope as an anchor for my soul.
> Amen and amen.

Section 10

And God blessed them and said...

Be my hands and feet.

And God blessed them and said...
"Be my hands and feet."

I remember a sermon one Sunday early in my husband's ministry at a Lutheran church in a small rural community, where he used the theme of being God's servant. Following the service I became engaged in a conversation with a fellow member at which time we discussed the possibility of a community outreach project. As I cleared my desk that evening, I found a favorite book in which I had written a note to myself, recalling an experience of going out into the world as a servant. Interesting how all the "servant" messages seemed to be accumulating.

As I am working on this chapter it is yet another Sunday evening. I am not necessarily writing the chapters to their completion in the order in which they come in this book and I had to smile when I opened the file to read my notes for this chapter and was once again reminded of my thoughts about being a servant. Here I am again with the same theme boldly reaching out to catch my attention. Once again I am considering what it actually means to be a servant. This seems to be a theme that just won't let us go! I am getting the message loud and clear – there is work to do!

God came up with quite an idea when he worked us into his creation plan. Now, are you ready for this...he said, "I am going to live in you but you will be my hands and feet. Go out and serve. You only need one coat. No walking stick." My response? "Lord, are you kidding!" Who am I going to help and I can tell you that one coat is not going to be enough! Maybe if I can find some good folks who would share an extra walking stick with me I just might consider it.

No, that was not God's plan. We are to be servants without analyzing the situation before we start our servant work. "But, Lord, I don't even know my own neighbors!" And I hear God reply – "Then get out there and meet them! There is work to do."

The first parish my husband served was in a rural Appalachian community. We were young and full of energy and thought we knew everything. It didn't take long to realize that serving in the real world was a bit different from simply "discussing" it. We had much to learn about just how God wanted his hands and feet to work. A unique friendship developed during those months in southeast Ohio. Through my husband's work we met a native West Virginian who was a Catholic priest. We quickly understood that we, newcomers to the area, had a lot to learn. This man who had been born and raised in this region of the country understood and lived what it meant to be a servant to the people in his neighborhood.

It was near Thanksgiving when our friend discovered that he had an inoperable brain tumor that would soon end his work as God's hands and feet on this earth. My husband preached at his funeral and shared such appropriate words from Matthew 25. God's purpose for breathing air into our lungs and life in our hearts was simply so that we could work for him, sharing a cup of water, giving someone a coat or even the difficult task of visiting a prisoner in jail. Hearing these words through tears that day, I realized how serious God is about our role as servants here on earth. There still is so much work to be done. We were young at the time and just discovering the purpose of our lives, a discovery that continues on a daily basis.

Many years have passed and my husband has retired. Prior to making this final move, we answered a call to spend the summer serving as hosts at a bed and breakfast for a Lutheran retreat center. What a summer! This was not just your run of the mill bed and breakfast. We were the last stop before our guests boarded a boat that would transport them to the base of a mountain in another area of the Cascade Mountain chain, two and a half hours by boat on Lake Chelan. At that point they would leave the boat and board a bus that would carry them up and up, over hairpin turns to a remote area in an incredibly beautiful location. Finally they would reach their destination.

Our guests at the bed and breakfast, of which there were often a dozen each night, were bound for a very unique experience. This was a spectacular place to spend the summer but I most certainly worked hard. We truly were servants in our new setting. I left our little house on the side of the mountain by 6:00 a.m., walked to the B and B through an orchard and past the small

dwellings that housed migrant workers to greet our excited guests, already up and ready for their morning cup of coffee.

The air was mountain fresh. Conversation was spirited. The atmosphere was filled with excitement and anticipation. Being a servant that summer brought mixed feelings. Oh, I worked hard preparing a delicious morning meal, baking, tending to the flower gardens and always the laundry and cleaning. But...each day I walked right past the humble houses of the orchard workers. What I did each day was important and worthwhile. What I didn't do each day was also important. Each morning as I walked past these strangers I am not sure that I totally served God with both hands that summer. There was an opportunity right on my path that I ignored.

One of the long-term residents in the village came down from the mountain and took a couple days break at the B and B. This individual had retreated to the village to ponder some personal issues. As we sat around the table sharing conversation, a comment was made about what a remarkable experience it had been go into the solitude of the village. In this remote and quiet environment insights were realized and doors opened.

I pondered this snippet of conversation for some time. Wouldn't it be remarkable if we could "go out into the world" rather than retreat from it. What if we felt the same inner satisfaction as we go out into the world, being servants to our neighbors, tending to their needs and concerns.

It's about balance. We do need quiet, meditative time but we must remember that balance and also make time to be doers of God's work as well as care for ourselves. We need to learn to find the peace and strength in our hands and feet as we live our daily lives, reaching out to others in need in the world, doing what God truly expects of us.

God doesn't ask that we give up our dreams. God doesn't expect us to forego our own well-being because we are so busy caring for others. But do you know what? God needs us more than we need two coats. Even with all my "Ya but's" God needs me to spend more time walking with his people in need than I need climbing the ladder to satisfy my own needs. Two coats at the top of my ladder are more than I need. Okay...I don't think God was literally counting pieces of clothing but there is no question that God is counting on me.

My cousin and his wife recently retired. She is busier now that ever, working in her kitchen on a mission. As she described her "retirement" she said "I have a kitchen ministry, providing goodies to people who need a hug." God needs us to be his hands and feet so that we can pass his hugs onto our neighbors around the block and around the world.

Quieting your mind...

Even in the "busyness" of being the hands and feet of servanthood, it is necessary to quiet your mind and your body. In every day of your life you must pause, even if it is just for a moment. In that still moment, listen for the words "Surely the presence of the Lord is in this place."

In a quiet moment remember God's presence within you and remember how important your presence is to him.

Remembering and exploring your thoughts...

The Calendar page...

There is a beautiful calendar taped to the side of our refrigerator. Twelve days had already passed in this current month before I remembered to turn the page to a new month. When I realized that last month's notes were continuing to remind me of commitments and responsibilities, celebrations and appointments, I stopped in my tracks. I have been writing all these chapters giving you the directions to do as I say, not as I do. I'm definitely not following my own advice.

How quickly we lose track and our calendar pages remain unturned. How many times a day do I walk past my refrigerator yet I am often unaware of just how busy I am. I don't even notice the beautiful images on my calendar! Too busy to be aware of this day that the Lord has made! If I am to be God's hands and feet, I must care for myself – day by day.

You probably have a calendar on your refrigerator or on your desk. Arbitrarily, mark an X on four calendar spaces, one in each week of this particular month. This is your "day of awareness". This is the day during which you are going to consciously consider the work that God has set before you. This is the day when you remind yourself that surely the presence of God is in this day. (I know, we should do this every day but this will at least get us started.)

When I don't take time to immerse myself in this presence of God my hands and feet begin to move about mindlessly. When there is a lack of awareness in my hands and feet as I move about my day I lose focus. I begin to consider all that I have missed in the moment…celebrations, blessings and dreams are passed over. Stress dominates as hope and pleasure go off into a corner. If I am to feed others, I must remember to partake of God's blessings myself.

So how are you going to relish your heavenly meal? How are you going to remind yourself to fill your own cup? How are you going to remember that God needs energetic workers?

Maybe you try post-it's by the calendar or writing with colorful markers on recipe cards. Red notes to remind you of your "cup-filling" needs and blue notes to remind you of today's outreach plan.

You don't have to care for everyone in one day nor do you need to be caring just one day a week. This is your reminder for one specific day, each week, this month. This is your reminder that you must partake at God's table and that you must fill you own cup so that you can have the strength and motivation to meet the challenges of being God's hands and feet.

Don't spend all your time making notes…God has work for you to do!

Try this with me...

Much too frequently I become more focused on the need to accomplish the tasks on my own personal list of "to do's" than to remember that my hands and feet have been called to a ministry that reaches far beyond my needs. When my being so busy overwhelms me I find writing in my journal gives me a refocusing opportunity. Opening my journal is much like putting up a sign that would say "reduced speed ahead." With pen in hand and a blank page before me, I begin to slow down both in mind and body.

I have a favorite pen...one that feels very pleasurable just to move across the paper. And I write. For me, as I write, my sense of awareness kicks in again. My mind becomes clearer and I am reminded of the task to which I have been called – that of being a servant.

Give this a try. Get your journal out and use it on a regular basis for as many days as seems to fit this section. Think, if you would, about some aspect of your life that you consider to be your ministry. Remember my cousin and her kitchen ministry!

As you write this month, consciously consider what God has requested of you as he invites you to be his hands and feet. We don't need a resume nor is there a fear of being dismissed or demoted in this job. And how do you respond? Why? When? Where?

Be very aware of the presence of God in that particular place because surely his presence is there. Remember the words "I can feel his mighty power and his grace." Write about that presence and the power and the grace. Write about your hands and feet and how they brought God's presence to someone, either in a significant way or in a very simple and humble way. What power was there in your actions to challenge or to make changes? Who became aware of God's grace because of your love?

Remember how God's presence made a difference – through your hands and feet.

One more thing...

In the quietness of the evening consider all that God did for you this day. Maybe the blessings were in technicolor today. It might have been a day of subtle gifts, the kind that cause you to say "God, you really did notice."

And remember the words of the Psalmist who asked God "What are we that you, in all your glory, are mindful of us each day?" If God is so focused on our minute by minute needs, how much more are we directed and challenged to reach out to the needs of our neighbors.

A prayer for hands and feet...

Lord, there is absolutely nothing remarkable about either my hands or my feet.
But how thankful I am that you have given both to me.

Lord, I tend to get so busy that most of my energy goes toward using my hands and feet to benefit myself.
But, that isn't the intent of your plan for my life.

Lord, guide me to those places and people who can have their cup filled from my cup that so often overflows. Remind me that I can be very content with just one coat.
Amen and amen.

Section 11

And God blessed them and said...

Ask
and it will be given to you
Seek
and you will find
Knock
and the door will be opened.

And God blessed them and said...
"Ask and it will be given to you, seek and you
will find, knock and the door will be opened."

Life can be challenging! Sometimes it might seem that there are more doors that remain closed rather than open. My husband and I recently sold the house where we lived before the move to this new community. I know we just accepted some of the quirks and flaws of this house while we were living there. In preparation for a sale, though, everything had to be in top-notch working order. It seemed that we experienced one frustrating expense and delay after another. Just as we completed one repair job, another appeared.

The community where we now live is experiencing job layoffs in numerous plants and companies. It seems that businesses everywhere are downsizing and cutting back. This is probably just the right plan for them but workers are losing their retirement and health benefits, which for some people are resources that will be needed just around the corner. Indeed, there are times when the door seems to be latched from the other side.

Interesting that this chapter is one of the more difficult ones for me to get organized. I think it is because I'm so close to the thoughts

I want to share with you. I would imagine that we all experience, first hand, doors that remain closed. In my case, I think one of the reasons this is a challenge is that I am so focused on the actual problems at hand! When I get into one of these grooves, or better described as "ruts", all I tend to focus on is the problem rather than opening myself up to the solution. It's the closed door or nothing at all! Someone at work put it so aptly, "We tend to 'admire' the problem."

It is also interesting in this story from Luke 11: 9-10, that Jesus puts the solution before the problem. Jesus puts the action verb before the promise. Do you think we might have the tendency to begin by saying, "Beware, there are many doors in life that will be closed!" Do I get my defenses up just to protect myself against all those things that might possibly go wrong? Go ahead. Try it. Ask. Seek. Knock. It will work but, human that I am, I just continue drifting in the muck and mire of "I can do it myself."

Before the challenge manifests itself into a full-blown problem – KNOCK! You just might be surprised at what happens when a door is opened. Jesus doesn't say, "Wait. Let me check the peep hole first." Actually, in the promise the closed door isn't the problem. I am the problem. I am the one not asking or choosing to simply remain in my situation. How reluctant we are to accept this amazing offer Jesus makes to us.

Jesus recognizes my needs, great or small, and offers some action verbs. As I understand, the call to action is directed at me becoming involved in the process and the result of my asking, seeking and knocking is met with a promise from Jesus. I will find the answer and the door will be opened. There are no maybes, no qualifications, no reservations…just a promise.

Do you know another piece of this problem? Too frequently, I would like the answer on the other side of the door to be "my" plan. For some reason, I become so stubborn and so immersed in the problem that I don't even consider asking or knocking! I wanted our house sold "now" and that was all there was to it! We cleaned and painted and repaired – so what's the problem? I was (and still

can be) so busy stewing that I wasn't quiet enough to listen or to be open to seeking God's assistance.

Lord, I am knocking and listening. Help me to open the door to my mind and heart. Lord, you must get more than a bit frustrated with me since I tend to take over for you on more than one occasion. You probably don't need me to step in for you.

Can you remember hearing encouragement from others, "You can do it!" We are challenged to do better because we have the power within us to accomplish what we set out to do. There are some pieces missing here – such as, "With God's help"...I can do it or at least feel confident in making the attempt. God is the power within me. I do have the potential to find the solution or to accomplish the task but the success comes with God's power.

That's pretty confident talk and I have to be honest here. I don't think that every knock brings a quick and easy answer. Another important piece is that I understand the answers aren't always going to be on my time-table or that I might not even recognize the answer. Seeking a path can be as difficult as finding an unfamiliar road on a map. The answer will come, the path is there – the door will be opened. Someone did buy our house!

Our nation will recover from political mistakes and financial failures if we ask for direction. Peace and brotherhood are possible if we seek a path that leads to love and caring for each other, not violence. Doors will open but we must knock. God's doors aren't stuck and the keys aren't lost. There are answers to unemployment and relocation and feelings of hopelessness. God does know that we tend to be stubborn. His patience outdoes our arrogance. There are no limits on his guarantees and promises. The gift is there for us but God isn't pushy. God is the one who is confident.

We all have our "Monday mornings" when we find ourselves back to facing whatever challenges are on our hearts. This was a difficult section to consider for my theme of God's blessings. As I write, I am discovering it was also time for me to stop and be reminded to ask God for some guidance, to seek wisdom from one who knows the answers and to knock with confidence, knowing that God will

fling that door wide open. Hmmm, one day I just might have to come back and add the next chapter on this thought...Developing a sense of awareness and understanding more about acceptance when it comes to this invitation just might require living through a few daunting life experiences.

I shared this book with a friend during the writing process. When she came to this point she had an interesting observation. It felt, to her, that I do still have more on my mind. This is such a difficult section of scripture yet so comforting. We are directed to a specific action and are pretty much promised that there will be an answer. You will receive. You will find. The door will be opened.

What if I don't like the answer? Maybe what I find isn't what I expected. Who knows what is going to be behind the door when it is opened? I can't answer these questions. As I said, if I am honest, I don't always like the answer and I can't always find what it is that I seem to be seeking. Like my friend, it is frightening to think about those unknowns behind the door.

If I were going to try to make sense of those three words and the promise that comes with them I would have to go back to all that we have previously shared. Answers won't always make sense... to us. Somehow I must trust that God has the big picture and, right now, I can only dimly see. I can't rest in my fears. True, it isn't easy. Some challenges in life are just more than we ever want to experience. Look back over the blessings written on the calligraphy pages. Acquiring and developing our faith and trust is a gradual process. It is a journey we don't travel alone.

This might be a good time to stop and seriously consider again, that most significant challenge in your life. It might be a financial concern, an illness, family struggles. Just choose one thought and then approach that mindfully with each of those words: ask, seek and knock. Give God your questions and fears. Don't begin asking for help when you already think you know the answer. Don't go seeking when your mind is full of clutter and you don't know what you are doing. Don't try to knock on the door with your hands full.

Can you picture putting your hand in God's hand? Can you visualize God holding you up? Close your eyes. Breathe deeply. Don't run on ahead. I don't have the answers and I don't always understand but maybe, just maybe you will feel God's presence and a prayer will be answered, a direction will be found and somehow, a door will be opened.

Quieting your mind...

It sounds so simple and you are so definite, Lord. No "maybes" or "I'll think about it." The promise is that it <u>will</u> be given, I <u>will</u> find, and the door <u>will</u> be opened. I stumble over myself sometimes, trying to answer my own questions and find my own solutions. I am so thankful that you, God, are the doorkeeper. No maybes. Just promises.

Remembering and exploring your thoughts...

The Calendar page...

Our time together is winding down. You are reading through the final pages of this book. Do you have anything in particular that is capturing your attention these days?

My husband and I are just beginning our retirement experiences. We've been getting older for some time now. Being quite practical people, we have done all those things one needed to do to be prepared to retire. Then one birthday, my husband commented, "You know, the days for which we have been planning are here!" I calmly agreed but with that rather startling statement, I became the Queen of Worry. Thinking about retiring and doing it are two entirely different things. It was the financial aspects of retirement that weigh on my mind. I eagerly looked forward to a calendar that would be planned more according to my whims but the money –now that's scary.

Needless to say, preachers and teachers aren't generally in the high income bracket. I know we will have "enough" but my fears shout in my ear that we need "more"! I pay the bills and take care of the banking business, but the stock market...now that seems like a zoo out of control to me. Stocks. Bonds. Annuities. Health insurance. Down-sizing. I even thought that maybe our house wasn't selling because we weren't supposed to retire. Now how silly a thought is that! Both my husband and I think that we should know it all...and we don't!

Think back to what we began during the first part of this section. I suggested that you choose one thing, just one concern or challenge facing you at the moment. Focus on the issue at hand. In my case, it would be continuing to live in a peace-filled direction as we enjoy our retirement years. Now go beyond what we initially we were discussing.

Focus on these three words: Asking, Seeking, and Knocking. Choose a way that works best for you...writing, talking with someone, reading...whatever suits your situation and is the most helpful.

ASK. For what? For me, it would be guidance, encouragement, and support as I challenge my fears, wisdom, common sense and patience. And then I must be quiet to listen to what God has to say to me.

SEEK. I need to listen in order to understand that what God has to say about finding a path that will provide some solutions and directions, some plans and support.

KNOCK. Definitely, I must knock. I just might be surprised at what is behind that door…and what God has planned for us. But… that door will open.

Go back and reread parts of the Blessing section. Sit quietly as you consider questions and fears that you might have. God is big enough to handle any doubts that might challenge us. Do you remember what I said in an earlier section about the importance of tears? At another time we talked about the need to be held up by someone stronger that we are at the time. It's difficult to find answers when we feel empty. I don't think God can "fill us" when we are busy running in the other direction. Remember again the words to the song, "In Your Presence". It is there that we are going to find the peace we seek.

Use as much time as you need for these thoughts. Some days might be better for asking and others might just cry out for seeking. Maybe the knocking is meant for later in the process but do them all. Jesus didn't just suggest one and he didn't just make one promise. When you awake tomorrow morning, the first thing on your agenda is to open yourself to the promise with one of God's action verbs. There is nothing passive about this assignment.

Try this with me...

I would like to use the words of Jesus from the Gospel where Luke reflected back upon the life of Jesus. Ask, seek and knock...and God will pay attention to you. I would like to help you begin developing a plan to create another collage.

The process of creating a collage was introduced in Chapter 3. Remember how you saved papers of different colors, tore images from magazines, sorted through odds and ends...do that again but this time the collage is going to be in the style of a tryptich.

During the Middle Ages, alter pieces were made as tryptichs. Visualize this with me. In the center section was an image that focused specifically on the main subject of the alter-piece. The two side sections were hinged so that they could fold in, each side covering half of the main center area. These two outer pieces would have complimentary or secondary images such as a portrait of the donor who sponsored the making of the alter-piece or maybe another character directly related to the main image. You have probably received a brochure for some meeting that was designed in a similar style. The main purpose is that there are three sections...one in the center and two others, one on each side.

Stop and think awhile, reflecting on those three words... Ask. Seek. Knock.

Maybe you have already reached out, asking, hoping to find but you just haven't received the answer yet.

Choose one word or thought for the center section. Let's imagine that it is "knocking". What would you like to find behind that door? What would you want that answer to be? Maybe your prayers are for a family member. What images could you use for the center that would remind you of that particular person? Or maybe words would add to that message or thought. Color speaks so clearly sometimes. Consider using various textures of colored papers, such as wrapping paper, scrap-booking papers, glossy magazine colors, etc. If knocking

becomes the theme for the center, the side panels would address asking and seeking.

What do you most want to focus on for a theme…good health, peace of mind, safety, courage, a growing faith? What need for guidance is on your heart? Here again, maybe writing would be more helpful to you than images.

You might be just in the beginning stages of "asking" and that merits the center panel. Life has been hectic and you just are asking for direction toward more peaceful times in your life. Begin by asking for help to find calm in your daily tasks. One step at a time. If I were going to consider an image for seeking after calm and peacefulness, maybe it could begin with a scene related to water, for instance. Or even colors related to the peacefulness of calm water.

This process could begin to be a visual journal with the same three words but a change on the main focus. Maybe, one time you could use all three spaces for writing and another time it could be images and still another time, it might be a combination of the two.

The "process" offers the opportunity to reflect and ponder in your heart what it is that is on your mind. The creative action of writing, cutting, painting, or pasting somehow offer a strong connection to what you are experiencing in your life.

This is not meant to be "hang it on the wall" art. Rather, it is a personal image, a process that simply but deeply speaks to you. As you sit quietly, meditating and considering your plan, be still and listen for an answer, be aware of guidance, and find the courage to knock, knowing that there will be an answer.

One more thing...

These are incredible words. Read the text in the Gospel of Luke, Chapter 11, and pause after each verb.

Breathe deeply.
Ask from the depths of your heart.
Jesus said, "It will be given to you."
Breathe deeply again and with your eyes closed, "look" for the answer.
Jesus said, "You will receive it."
Breathe deeply again and see that door in your mind. See your hand meeting the wood on the door and see that no sooner did you knock, the door opened.
Jesus said, "Knock, and the door will be opened."
Breathe again.

Maybe this could be your prayer each morning or evening...even for those days when we are afraid to ask, seek or knock because we aren't sure what we will find behind that door.

A prayer for reaching out to a real God...

Lord, I would ask but I often think that I should already know the answer. It seems I've asked so many times.

Lord, it seems like I am always seeking this or that. Help me find what it is I really need and help me be at peace with the answer.

Lord, you make so many promises. You simply said, "Knock." I ask that you give me the faith to believe that you will open the door. I seek the right direction so that my faith will grow and I

will believe that you will open the door. Hold my hand when I fear what will be behind the door.

Lord, how awesome that you have an eternal and everlasting welcome mat!
Amen and amen.

Section 12

And God blessed them and said... Welcome Home!

And God blessed them and said...
"Welcome Home."

My husband and I enjoy traveling, visiting new and different places. Sometimes it might just be a day excursion, other times an extended vacation. Do you know what – even though we are seeing new places and doing new things, after the journey, I really like coming home! It just seems so familiar to open my own refrigerator to check what leftovers are there to make a meal and to be able to sleep in a bed that knows me. Home is a good place for me.

Jesus knew he was about to leave his friends. As joy-filled as he was, knowing he soon would be "home", he also recognized that his disciples were already grieving. What comforting words of assurance he gave to them. "I am going to a place so magnificent – my Father's home – and I will prepare a room there for each one of you."

What do you think those disciples must have been imagining? For them such a thought of Jesus going away brought an ache to their hearts. There probably were a few large buildings in their neighborhood but a place that would have a room for everyone – that was hard to believe!

Indeed, Jesus has gone to prepare a place for us in God's mansion. There was a home for sale in our community that contained five bedrooms and five baths. Even at that size, the disciples would have had to double up. Jesus promises everyone their own room! For today, I simply have to trust what Jesus has promised. He didn't say he would

scout around for a place. No, he was quite definite. "I am going to prepare a room for you in my Father's house."

I thought about that prepared room quite a bit on those fearful days when I was receiving treatment for breast cancer. It was difficult to imagine the journey that was ahead while I was in the process of recovering from the initial mastectomy surgery. This journey was filled with unknowns. Being in that hospital bed that first night, I just so much wanted to be home.

What if the surgery hadn't removed all the cancer? What if the chemotherapy didn't zap what was left? What if the radiation didn't clean up the leftovers? How would I know? Unknowns open the door to so many questions. More than once I wondered if maybe the room Jesus was preparing for me might be occupied sooner than I had planned.

Recovery wasn't easy. Recovery never is. Recovery is work…hard work. Often, in recovery, we find ourselves in a place that doesn't feel much like home. It's somewhat like being in a room worrying about goblins under the bed and monsters in the closet.

Jesus said that he was going on ahead. Comforting words they were. He had been to God's house before. He knows the way and he is confident when he tells us that, indeed, there is room for everyone. Jesus is so sure about this place that he promised to get a room ready just for me.

It has taken me some time to begin letting go of the fear of the cancer returning. There was a long list of "maybes". Maybe I should go to the doctor more frequently. Maybe there were more tests that could reassure me. Maybe there was something the doctor was not finding or even worse, not telling me. Healing is a process. I gradually understood that there are no guarantees of "being cured." Gradually, I learned what God means by "healing" and the guarantee that comes with that.

I've been writing these chapters for some time. There have been dreadful events happening in the world. Traumatic changes have occurred in the lives of people around me. Some days I wonder why God would even want us at his house…but I know he does. That's the plan. Today is a glorious day. Just perfect! As I sit in the backyard writing, I am almost overwhelmed with God's plan. I sit here with the warm sunshine on my back and I begin to wonder if I have already arrived at God's doorstep. I think this must be a foretaste of the feast to come!

How do I know that this is God's plan? How do I really know that God talks to me just as he did to Abraham and Moses and all the others? How do I know that even when life seems confusing and frightening, God is still keeping his promise? I know that by looking back at yesterday, recognizing that when I am on my own the days don't always go as well. When I am on my own, I feel empty and without focus. When I look back, the evidence is strong that only God's hand holding mine, leading and guiding, has managed to maneuver me through the most difficult and disruptive of times.

And today, living in this moment, I remind myself to slowly and mindfully remain in that present moment. Tomorrow it might be a bit clearer as I look back and see how God remained by my side throughout the day. So, because of all the "yesterdays" in my life I can recognize that God does answer prayer. Looking back, I am assured that God does have a plan and that the invitation to move into his house is for each of us.

Lord, I can look back and see the evidence but I need help with today. I don't always pay attention to your promises. I sometimes question them or try to intellectualize as I work to explain them. Maybe if you came to my house right now and sat down beside me I would listen, right now. But then I remember that you are here – as much a part of the day as the air I breathe or the sunshine I enjoy.

What if I truly lived as though I believed you were in each and every day? What if I took time to talk with you each morning? What if I really believed that you have a place for me in your house? If I really believed that my bank account and retirement plan should not be a driving force in my life or that my work should not consume more time than my time working for you...what if I could do that! You are God and you made a promise to care for me. Open my eyes, Lord.

Such an awesome God! Such an awesome promise! Whether it's walking through illness or any other kind of tragedy, that promise will carry us through. Whether it's walking in prosperity and celebration or struggle and challenges that promise is greater than anything we might do on our own. Help me live in your presence and in your promise. Lord, be with me on this journey that will eventually lead me "home".

Quieting your mind...

There will be no goblins under the bed and no monsters in the closet. There will be no worries about paying bills or having adequate resources for retirement. There will be no fear of war, no pain or illness. There will be no loneliness, no searching. There will be no needs of any sort.

We'll recognize your house, God. The front door will be open with your outstretched arms greeting us. Remember the slogan… "We'll leave the light on for you." God will not only leave the light on…he will be at the door waiting up for us. Remember how concerned we were about knocking on the door in the previous section…we don't need to worry!

I'll recognize my room. Jesus promised that he had gone on ahead to prepare it with absolutely everything I need.

I'll recognize that I am in your house, Lord, because I'll remember that song, "The presence of the Lord is in this place. I can feel his mighty power and his grace." I can feel his mighty power and his grace. It's an amazing grace you offer, God. Thanks for welcoming me home.

Remembering and exploring your thoughts...

The Calendar page...

The experience of writing these words has been a process as much for me as for you. Living day to day is always a process. I can remember, as a young child, thinking that one day I would be grown up. Some days I smile to myself, wondering when that will happen.

During this process I have experienced two thoughts – one is that I am always in the process of discovering who I am. The other is that even though I am officially a senior citizen, there is still so much to learn about myself. Some days I look in the mirror and my eyes meet the eyes of a stranger. Other times I am so comfortable with the face that is looking back at me. So many changes and even more to come!

It's comforting to know God has known me all along. (Psalm 139) I've not been alone on this journey. God, indeed, has created me in his image. I probably would have made some changes – a bit taller, a lot thinner, maybe just a bit smarter, and curly hair for sure. I think I better look back to the first chapter to be sure I underlined the parts where God said, "It is all good." He created us just as we should be.

How about trying this final project together? Create two parallel writing spaces. For some, it might look like two separate notebooks; for another person, it might be a large sheet of paper with a vertical line drawn down the center, top to bottom. Think back over the time we have spent together. Consider the words we have pondered together… beginnings, journeys, faith, questioning, trust, celebrations and creating, fear and hope, being guided and reaching out as well as the challenges of not listening or paying attention.

Label one column to identify times you have experienced positive growth related to that word and on the other side, times when those words have been a challenge. Consider the beginning of this growing process, consider the journey and the courage and assurance that God is always with us and then give some thought to what "going home" means to you.

Such a life this is! Thanks for spending some time with me. I wish you could meet me for lunch or join me at my kitchen table. Even

though we are not able to actually meet, it's been a pleasure traveling with you through these words and activities. Somehow, I think we are connected as we all make our life journeys, a connection deeper than we can really understand as we gather as one – as God's people in God's world. What a joy! So, in some way our journey continues…together.

And now…Go in peace. Serve the Lord. Thanks be to God!

Try this with me...

You are probably going to think this idea is kind of silly – and you certainly can have fun with it – but I am quite serious about this process.

First of all, seek out someone you can trust. No suggestions. You decide who that might be. You will need a camera. Any kind will do from an inexpensive disposable camera to a state of the art digital camera.

Arrange some time with your trusted companion. Invite this person to photograph you. You got it…the whole film will just be photos of you! Consider the environment, what is going on in your life and how you are feeling…but all of the photographs are of you! (And I trust that there is no question that these are all in good taste!)

Have fun. Be serious. Be silly. When the photographs have been completed, develop the film and then sit down alone - just you – to look at "you". Are there some surprises? Do you appear more comfortable in some shots? Do you resemble anyone in your family? Are you able to see deep into your soul in any of them?

Complete this process with a bit of writing. Put these photographs in some kind of journal and write about your reactions and responses as you ponder who you are or who you have been – as well as the person you are becoming. Have a wonderful time. Think of me and I will be doing the same…growing and thinking of you.

One more thing...

My last thoughts are words from God's book, words I would like for you to carry in your heart, whatever the day might bring.

John 14: 1-3

And Jesus said to them, "Do not let your hearts be troubled. Trust in God. Trust also in me. In my Father's house there are many rooms; if it were not so I would not have told you. I am going there to prepare a place for you. And if I go and prepare a place for you, I will come back and take you to be with me that you also may be where I am. You know the way to the place where I am going."

Prayer for "going home"...

Lord, we have walked a long way together. Sometimes I have wished I could have been like Moses, seeing you face to face. But maybe I have seen you face to face in the eyes of your people whom you created in your image, people who are my neighbors.

Lord, thank you for the journey, for both the roses and the thorns. You promised a garden where we could feel a sense of peace more than we could ever imagine and I believe that is what is in store for us.

Lord, thank you for the beginning, the middle and the end. And thank you for the promise of a very special place to call "home".
Amen and amen.

Rejoice
Today!

This is a day the
Lord has made.

Devotions for Each Day ...

Here are 31 thoughts…one for each day of a month. The calendar year has twelve months so, basically, this plan arranges the thoughts for any given month. These devotional thoughts are designed so that they can even be repeated at the end of the month. There are no two days alike in our life and each time you sit down to consider a thought, there will be a new meaning behind it. All that said, make the journal suggestions fit your style or schedule.

Develop your own style. Rearrange the devotions. Copy the beginning thought that is suggested and enter it into your journal. Maybe you could create a small drawing of the image you chose to use earlier in the book. Your perspective on life and attitude about things in general will change during the month. Each month will find something new on the "front burner" of your life. You might be concerned about your health, a relationship, an experience at work or possibly with your family. As you go through each of these phases in your life, new thoughts will occur to you as you repeat the process of these devotions.

If you use your journal or a sketchbook as you work your way through the thoughts during one particular month, you might draw or paint your expressions rather than using words. One month you might keep all the thoughts to yourself and the next month, perhaps

try sharing it with someone. Be creative! Use what works for you and get rid of the rest.

Each month provides an opportunity for a new approach. You are not the same person, with the same thoughts, two days in a row. There is space right in the book for you to jot down your thoughts so that you can reflect back on them as one month leads into another. Maybe you decide to proceed through the month using a calendar, incorporating your spiritual devotions in the morning or in the evening. Consider using a specific verse from Scripture as a companion to the thought for the day. Have some fun doing a little research to find just the right verse to compliment your entry.

Consider each day – thoughtfully and prayerfully. The process will make a difference. Courage, strength, faith…and good health do not happen by wishing for them. It is a process…working, getting your hands dirty…one day at a time. It is being aware of God's guidance as we learn to trust and accept the process of becoming the person God intended us to be.

1. **AN UNFINISHED JOURNEY –**
 No matter what my age, there is still a piece of the journey ahead of me.

2. **NOT GETTING THE MESSAGE –**
 Sometimes I choose to live with the stress rather than work through it.

3. **SECURITY IN UNCOMFORTABLENESS –**
 Sometimes I find it easier NOT to consider the process of making changes.

4. **NOW WHAT DO I DO –**
 Some days I feel as though I have "cancer of everything" (or whatever your physical challenge might be)...I can't seem to find the way.

5. **LOOKING INSIDE –**
 When I look in the mirror and I think about how I am feeling, I wonder if others see what I feel?

6. **IT HURTS –**
 I can laugh on the outside but inside…that's a different story.

7. **MY ATTITUDE –**
 They say attitude makes all the difference in the world…and in the healing process.

8. **PREPARING FOR THE JOURNEY –**
 Sometimes I don't even know where I am going.

9. **NOT KNOWING HOW TO PREPARE –**
 I don't know where I'm going and I've never been there before… how do I know what I need?

10. **NEWS FLASH –**
 Just when it seems nothing is going right, a new rainbow appears in the sky.

11. **LEARNING –**

 Sit quietly and think about what there is to learn in order to move securely along the path.

12. **BEING OVERWHELMED –**

 Sometimes it is exciting to learn new things and on other days I feel like I am the bowling pins and the ball is coming down the alley.

13. **DARK SHADOWS-**

 I can feel them but I don't like to talk about them. It's difficult to "feel" trust.

14. **FEELINGS –**

 Good day or otherwise…just stop and consciously think about what it is that I am experiencing.

15. **EXPERIENCES –**

 I don't need to reinvent the wheel…and maybe someone can learn from my experiences.

16. **I AM NOT ALONE –**
 Some days all I can see is my own face in the mirror but there are so many others supporting me.

17. **REMEMBERING OTHERS –**
 If there are those who are supporting me…and I know how good that feels…it would be good to do the same for others.

18. **I WISH YOU HADN'T SAID THAT -**
 I know people mean well but I wish he/she hadn't said that to me.

19. **DO IT TODAY –**
 There are so many important things I put aside in order to move on with things that really do not matter.

20. **DON'T WORRY ABOUT TOMORROW –**
 No one ever gained another day because they worried enough.

21. **LAUGH ALONG THE WAY –**
There is joy in my days and laughter opens my heart.

22. **BECOMING AWARE IN THE PROCESS –**
Awareness is the key to whatever I experience…it's the "Oh, now I understand" experience.

23. **I REALLY DID LEARN SOMETHING –**
Through all of life's experiences, it's good to know that it is possible to emerge as a wiser person.

24. **BE THANKFUL –**
In all I do, it is important to remember to give thanks…even for those things that seem to challenge me the most.

25. **BE HONEST –**
In all I do, it is important to be honest. It is unhealthy to store up untruths or to be fearful about expressing what it is I am thinking.

26. BE PATIENT –

So often I have to wait for what it is I want the most. Take a deep breath – answers will come when the time is right.

27. BE COURAGEOUS –

I do not need to be foolhardy, but I can be strong in whatever it is that I must experience.

28. BE ACCEPTING –

I can't change what has happened. I can only improve on what lies ahead. This is in my power.

29. STOP TO REST –

The journey is sometimes tiring. Even God took time to rest. Surely, I can do the same.

30. ENJOY THE VIEW –

It is a wonderful journey but I must remember to stop to enjoy the view along the way.

31. BE JOY-FILLED

It is important that I remember to acknowledge the source of my strength and guidance each step along the way...celebrate each step that carries me forward in God's love.

Philippians 4: 4-7

Rejoice in the Lord always. I will say it again: Rejoice! Let your gentleness be evident to all. The Lord is near. Do not be anxious about anything but in everything, by prayer and petition, with thanksgiving, present your requests to God. And the peace of God, which transcends all understanding, will guard your hearts and your minds in Christ Jesus.

Philippians 4: 12-13

I know what it is to be in need and I know what it is to have plenty. I have learned the secret of being content in any and every situation, whether well fed or hungry, whether living in plenty or in want. I can do everything through Him who gives me strength.

Just one more thing...

We have completed this particular journey together. Over the days during which you have been involved in this workbook with me, we have explored a variety of stories and experiences. Hopefully, that has helped you become more aware of the person you are meant to be as well as becoming aware of the path on which you are traveling. There is just one more story I'd like to share with you.

If you recall, at a couple different places I alluded to a "feather" story. I didn't go into detail but rather promised that I would explain later. It is a thought that I hope you will keep in your mind and maybe even use in your life. Consider this experience as a "tool" to assist you in becoming aware of all the "accidents" and "coincidences" that happen throughout your life, helping to carry you through those times when you might need a bit of a wake-up call.

In 1996 I was, as I shared with you, broad-sided with the news that the tumor which was removed was, indeed, malignant and the diagnosis was breast cancer. It had advanced far enough so that my treatment required a mastectomy, chemotherapy and radiation. As I described those experiences to you, that event in my life about took my breath away. Cancer is never an experience that we think will touch us personally. It is something that happens "to someone else". But here I was, ready to begin the routine of treatments that I hoped would rid my body of this dreaded diagnosis.

Chemotherapy was to come first. Radiation would follow the bulk of my chemotherapy treatments and when the days of radiation had been completed I was scheduled to return for the final chemo treatments. All during chemo I had been reasonably healthy, learning to rest when I needed and benefiting from supplementary medication when that was necessary.

I listened to a visual imaging tape made just for chemo treatment sessions and the time spent receiving my "red juice" passed quickly. My nurses were supportive and my doctors were informative. All had progressed as planned during those weeks and months. Now it was time

for my radiation treatments to begin and I realized I was experiencing some significant fear. Not being one who understood all the technology behind something as frightening as radiation being zapped into my body, I began to wonder if this was something I even wanted to do!

I was home alone one afternoon, resting on the sofa in our living room. The book I was reading was describing the author's personal experience with cancer and how important it was for him to visualize some kind of symbol or image that could be his focus during critical times of treatment. The pages I was reading detailed how he had chosen the image he eventually used. And then it happened...

Just at that moment, I heard a tapping on the living room window just at the end of the sofa. I didn't pay much attention and went on reading. The tapping continued. I looked over to see a beautiful red cardinal clinging to the window frame. There was no actual ledge so this little bird was making a real effort to hang on. I knew that birds tended to do that sort of thing so I just went back to my reading but that persistent little creature continued to peck on the window.

Once again I looked over at the window and at the same time a flow of heat actually surged through me, from my feet right up to my head. My body was flooded with a pleasant warmth. I walked to the window. It almost seemed as though that red bird was speaking directly to me. "What is it you are saying, red friend?" I wondered. I returned to the sofa thinking that there had to be something very unique in what was happening. It was as though something within was telling me to just "be still".

I went back to my book and to thinking about the upcoming radiation. I had been measured and marked. I thought back to being prepped for the treatments. The technician had drawn a large red cross on my chest. Red. Just at the intersection of the lines was the point at which the radiation would enter my body. A red light would shine down on that crossing of the lines. Red. I thought this was the color used for everyone but, as I later learned, that is not the case.

Radiant. Like the surge of heat that I had felt. Radiation. Light. Red. It was as though the red light and the red bird were carrying my disease right out the window! That was powerful to me! I had found my image and that beautiful bird stayed with me, at our house, throughout my radiation treatment days.

My husband and our daughter were with me at home and also enjoyed this visiting cardinal. We laughed about where he would be on any given day and, as always, he was right there where he could keep an eye on me. This was not just a story I was making up or pretending in order to find my special image. This little guy was real. This was my red bird.

He stayed in the vicinity of where we could see him from the living room window throughout the month, sometimes sitting on the mirror of the car that was parked close to the front of the house or on the fence just outside the living room window. Other times he would grasp that small window ledge. And then one day it was time for my last radiation treatment…and time for my red friend to move on to some other place. At the end of my treatments the red cardinal no longer was in our yard. I imagine he had other work to do! I have seen other cardinals but none have been so special to me.

But…the story doesn't end there. Plans had been made long before the cancer appeared that we were to be moving to a beautiful log home in the country. I had one series of chemo treatments left but knew that I could make it just fine even with the move that would happen during this last session. And besides, we were so anxious to be moved into this house in this wonderful location in the country. Our boxes were packed and we were on the way.

The house had been empty for several weeks. The purchase had been completed and no one had been in the house recently. A friend joined me as we arrived at the house ahead of the movers. Excitedly, I turned the key and we walked into the stuffy, closed up house. We walked through the living room and into the kitchen. Both my friend and I saw it and looked at each other. There on the floor of the kitchen was a white feather! No one had been there before us…especially a white bird flying through. There on my kitchen floor was a white feather! As surely as God had sent the red bird to support me though the frightening days of my radiation…just as surely God had invited an angel to pass through this new home and leave behind something that would assure me that I was not moving forward alone. There were no other explanations! Who am I to question the way God chooses to work! I picked up the feather. I had God's message in my hand. At the end of the day, I put the feather

in my journal where it remains…a constant reminder to be aware to all that is happening around me.

Somewhere there is a reminder in your life. It might not be a feather or a red bird but there is something that God is putting right in your path to remind you to be still, listen and move thoughtfully on your path knowing that God is right there beside you.

Think back to the blessings God has given to each of us. Exciting and sometimes challenging days. A faith made strong with God's help. A means to trust in God's plan. Learning more about who we have been created to be as God's people. Rejoicing in our dreams and realizing that we are created in God's image. God invites us to join him at his table, not running ahead but listening as we walk the path together. And always…the promise of a new beginning. God asks for our help as his hands and feet wherever we are. We know we can ask, seek and expect just about anything from God and when the journey is over, we can count on going home in style. Who knows, maybe I will float right up to God's front door on that white feather.

Oh, one might question the theology but that's okay. There are many mysteries surrounding this God of ours. Who am I to question if my God should choose to work his messages and miracles through red birds and white feathers.

I continue to use a feather as my "point of awareness". There is nothing magic about a feather but when one appears in a most unusual place I stop and think…"What am I to learn from this moment?" I might be walking on a beach, or cleaning up in my garden when a feather finds its way to my path. A feather may appear on a puddle made after a fresh rain. Whatever the situation, whatever the place, I am reminded that God is good and he is very close.

Feather experiences continue to bring a smile. I had been working on a project with a psychologist friend and early on had shared the feather/red bird story. We were planning some special events together, working with children. One day following a thought provoking session, we walked out the door to our cars. Right there in front of us, several beautiful, tiny feathers floated down. She just laughed and said, "Those must be for you!"

On another particularly awesome adventure I was traveling alone to the Grand Canyon. When I arrived at my planned destination guess

what…the name of my motel was The Red Feather. (You will still find this motel at the entrance to the park today.) I had been nervous about this expedition alone and when I arrived and saw the sign I knew I was in good hands. The "coincidences" continue and I still "collect" feathers. Hopefully, I will always keep this sense of awareness. The time for me to question the story is when I begin walking past the feather on my path and missing the messages.

Find your feather. Be aware of God's blessings in good times as well as in those times that definitely challenge us. Find your feather… whatever that might be for you. Learn more about who it is that you are…as one of God's very special people. Find your feather – be aware of the life you are living – as you experience this amazing journey on your way home.

As you travel through these pages, either for the first time or as you look back over thoughts and activities you might want to consider one more time…here is a prayer for you to keep close to your heart each day.

Each of us recognizes that there are good days and some that catch us off guard. We all know that some things go our way and other times we are not too pleased with the outcome. Our sense of listening and awareness varies with our experiences. We have sorrows and joys. It is all a part of being human…being the person God created us to be.

A Prayer at the Close of the Day...

It's been a beautiful day in your world, Lord. Actually the day has been near perfect. You made all your days perfect, Lord. Forgive me for not recognizing that. Forgive me for the discontent I often put into the most perfect of days.

Forgive me, Lord, for all the things I turned upside down today. Forgive me for behavior for which there is no excuse – except for the simple fact that I am human…but wouldn't you think I would eventually know better.

And on the nights when my heart is heavy, watch over me. Sometimes I feel so heavy because of the words, actions, and behaviors I chose to use today. There were times when I should have thought first. Comfort me when I recognize the blemishes with which I have marked up this day.

I can pray this prayer, Lord, because you promised another sunrise tomorrow. When I awake, Lord, remind me that my slate has been washed clean. I will be a part of your world tomorrow, whether here or in your house.

During those days when the joy that surrounds me is almost more than I can comprehend, nudge me if I forget the source of that joy. Just walking in your world and soaking up what you have created is totally awesome! Thanks for sharing these joy-filled experiences with me.

Grant me peace and reassurance as I end this day and begin another one tomorrow. Be with me in my restlessness and encourage me when I lag behind. Thank you for the blessings of this day and for the joy that has surrounded me. It will not be long before the Son rises on a glorious new day!

Thank you for your presence and your grace.

Amen and amen.

CPSIA information can be obtained at www.ICGtesting.com
Printed in the USA
BVOW07s1838170914

367296BV00001B/92/P